Professional

POSING TECHNIQUES

FOR WEDDING AND PORTRAIT PHOTOGRAPHERS

Norman Phillips

AMHERST MEDIA, INC. ■ BUFFALO, NY

Publisher: Craig Alesse

Senior Editor/Production Manager: Michelle Perkins

Assistant Editor: Barbara A. Lynch-Johnt

ISBN: 1-58428-170-7

Library of Congress Control Number: 2005922438

Printed in Korea.

10 9 8 7 6 5 4 3 2 1

Notice of Disclaimer: The information contained in this book is based on the author's experience and opinions. Th
author and publisher will not be held liable for the use or misuse of the information in this book.

Contents

Introduction

Every time I review an image, I learn something new or am reminded of something fundamental about creating photographs. You might think that is somewhat strange for someone who has been creating images for more than half a lifetime, but not one of us is so smart that we cannot learn from simply studying portraits created by our peers. Additionally, when we review our own work, we may well see that we might have been able to improve some of our portraits with better posing discipline.

WHAT IS POSING?

The word *pose* as it relates to portrait and wedding photography is an all-encompassing expression. Often, we discuss posing in a loose and too generalizing manner. We refer to the pose as if it were not specific, because no matter how we freeze our subjects with our exposures, they are in a pose.

The dictionary defines the word *pose* more specifically, as "an attitude or position taken naturally, or assumed for effect; an artistic position or attitude." It takes the description a step further when, in an additional definition, the term refers to the subject assuming "characteristic airs." It is this definition that applies most closely to us, the image creators.

OBSTACLES TO GOOD POSING

The majority of us are not aware of our natural and unconscious body positions, and so we do not present ourselves as well as we might. Most of us tend not to be concerned with how we place our hands, tilt our head, place our arms, and position our feet. Women, however (at least a significant number), are somewhat more conscious of how they present themselves than are their male counterparts, especially when it comes to how they place their legs. Their mothers have taught most young women what is, and what is not, ladylike. For instance, when women are in skirts, they will sit with their knees together. Men, on the other hand, are much more relaxed and are often careless about how they may be perceived.

NOT ONE OF US IS SO SMART THAT WE CANNOT LEARN FROM SIMPLY STUDYING PORTRAITS CREATED BY OUR PEERS.

■ GOALS FOR POSING

From the photographer's point of view, there is more to posing than ensuring a "characteristic air" in the image. We want our subjects to be shown in the best possible position. We want to flatter them, to make them look good. Yet, even in really excellent photographs, we can sometimes see flaws that, if corrected, would make the portrait more striking. When the positions of the arms, legs, and body are not well conceived, they can be disruptive or intrusive to the composition of the image. Attention to detail is the most important of our personal disciplines, and in honing our attention to detail, we can make a real difference.

■ THE PURPOSE OF THIS BOOK

This book will establish a code of discipline and provide sound guidelines for the way we present our subjects. It will serve not just as a starting point for those new to portrait and wedding photography but will also show my more experienced peers how to employ some old tricks, and perhaps some new ones too, in situations where they have at least a modicum of control.

In writing this book I was inspired by my observations when reviewing other photography books and illustrated editorials, competition images, and displayed portraits. I guess that I am something of a harsh critic, not just of other people's posing, but also when I err in my own images. Having said that, I believe that there are times when you will see merit in doing many things totally opposite to what I am advocating. Indeed, there are times when I do this myself and, when doing so, I frequently like what I have done. So I am also going to offer a few ideas as to how to present some interesting poses that are not exactly classic.

This book is not intended to be a pretty picture book, though some images shown may fall into that category. Instead, it is intended to be a manual of the many do's and don't's concerning posing. This book will cover the fundamentals of good posing and will show how to achieve them with the minimum of effort. Good and not-so-good examples are shown side by side so you can see the effect that making the recommended changes will have on the portrait.

■ A FINAL NOTE

If looking through this book helps you to avoid the posing negatives, you can logically expect to create images that are always acceptable. On the other hand, if you learn to take advantage of some desirable posing alternatives, perhaps your images will be amongst the best there are.

You will note that I do not address children's portraiture in this book, as I believe the subject is worthy of separate discussion. Especially when working with children under the age of six, photographers may find that their clients lack the control required to mirror the posing strategies outlined in this book.

> EVEN IN REALLY EXCELLENT PHOTOGRAPHS, WE CAN SOMETIMES SEE FLAWS THAT, IF CORRECTED, WOULD MAKE THE PORTRAIT MORE STRIKING.

1. General Principles

If we want our subjects to look good and to present them in a flattering way, there are four basic posing methods that we need to use: the formal, natural, and exaggerated styles, or a hybrid method that combines elements of the three former posing styles.

THE FORMAL POSE

The formal pose is that which presents the subject in a manner that is accepted in traditional portraiture. The female in this style is presented in an elegant, dignified pose. The male is presented in a manner that suggests he is gentlemanly and is a suitable companion for the elegant female. He will appear strong and supportive.

THE NATURAL POSE

This style will generally be relaxed and allow the subject to relate naturally to the camera. When subjects are allowed to present themselves in a *totally* natural way, however, they often look clumsy, awkward, or otherwise inelegant, so we will need to modify their presentation. This refinement should be subtle and should be carried out with diplomacy.

When you observe the two young ladies in examples 1 and 2, you will see that they do not appear to be conscious of the principles of good body presentation. Both examples show common positions that we will see when the subjects are not asked to pose. The subjects look relaxed and comfortable, but they do not look as good as they should.

In example 1, the first flaw is the position of their feet. The second flaw is that their hands and arms are shown in a less than flattering way. Their leg positions are far too casual and do not present the lines that make the female form attractive. In example 1, the young woman on the left has her hands hidden in such a way as to suggest a "photographic amputation." The hands of the young woman on the right look slightly deformed, and her left arm simply appears too passive. Her shoulders are turned at too

WHEN SUBJECTS ARE ALLOWED TO PRESENT THEMSELVES IN A TOTALLY NATURAL WAY, HOWEVER, THEY OFTEN LOOK CLUMSY, AWKWARD, OR OTHERWISE INELEGANT.

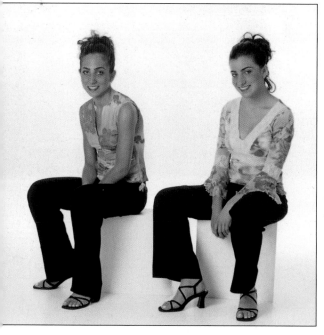

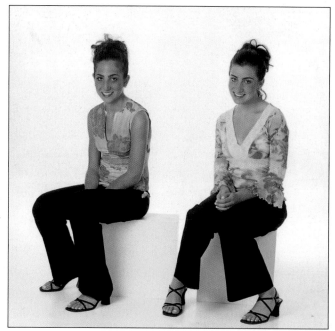

image 1

image 2

great an angle to the camera and therefore appear narrow; this makes her waist look far wider than it really is. In fact, she might well think she looks fat. That is a bad pose.

In example 2, the young lady at the right is in a common female leg position with her knees touching and her feet apart. It is an exaggerated pose that we can refine for the desired results.

■ THE EXAGGERATED POSE

In the exaggerated pose, we deliberately create a presentation of the subject in which they may not necessarily be comfortable, but from the camera position they look great, even dynamic. This style is for those who want their images to create impact and to perhaps present a dramatic attitude that transcends the personality of the subject. Some of these poses will be designed to portray aggression, belligerence or protest, or sheer exuberance. Such poses may also indicate depression or sadness, excitement or happiness, or even euphoria. Except for those trained to be very prim and proper and express themselves with pure language, humans generally use body language to enhance their verbal skills, and our images can do the same with expressive and creative poses. Of course, we need to make sure that when we use exaggerated poses they also present our subjects in the best possible style.

■ POSING BASICS

In other than simple head-and-shoulders poses, we should seek to create lines in our portraits that are attractive and make good composition. This requires us to have diagonal, curving, and circular lines in our composition, not boring vertical and horizontal lines. When posing women for a full-

length portrait, we want to create lines that are tapered and curved. In fact, unless we are seeking to present our clients with an exaggerated attitude, we should strive to create what we describe as an S curve.

When showing them in head-and-shoulders or half-length poses, we want the head position to reflect the personality of the subject. For female professionals, this may mean having the head angle in a strong presentation, or, in other words, tilted away from the near or lower shoulder, as demonstrated in example 3. For the traditional female presentation, the head is turned toward the shoulder nearest the camera to imply a more "feminine" attitude. In example 4, you can see that positioning the head in this way achieves a much softer look.

In general, head poses are not supposed to present the face squared to the camera. (The exception to this rule is the headshot that advertising photographers use when they want their model to "confront" viewers—and these can rarely be considered good portraits.) The typical headshot shows both ears and makes the face appear wider than it is. In most cases, this view is not flattering and presents a lighting challenge when modeling the facial structure of the client, be they male or female. Many headshots are really not much different than the ID photos used on passports and drivers' licenses, except that the professional photographer uses superior lighting and camera techniques. When we have someone posed squarely facing the camera, they often feel uncomfortable and have difficulty being themselves. Such a pose also prevents them from reacting normally to your prompting for good expressions. If you observe those you engage in conversation, you will see that it is rare for anyone to present themselves square to you. Everyone tends to slightly angle himself or herself away from the square position.

If you occasionally glance at the feet positions of those you engage in conversation, you will note that they are not positioned squarely toward you, but with one foot somewhat to one side and to the rear of the other, and they will often move their foot positions. It is only the aggressive, dominating types who square themselves to you. This latter character will also tend to lean their torso in the direction of his audience. This is an intimidating stance, and only when someone wants to convey this message in their portrait should you use this position. Another exception is when we are seeking to demonstrate a defiant or challenging attitude.

■ POSING DIFFERENCES: MEN VS. WOMEN
There is a distinct difference between the posing styles that are used when photographing men as opposed to photographing women. When photographing men, we normally will seek to create strong lines and lighting patterns, while when photographing women, we seek to make them look feminine and to achieve softer lines. While it is possible in some instances to pose women in men's poses, the reverse rarely works well. We will discuss these issues later.

IF YOU OBSERVE THOSE YOU ENGAGE IN CONVERSATION, YOU WILL SEE THAT IT IS RARE FOR ANYONE TO PRESENT THEMSELVES SQUARE TO YOU.

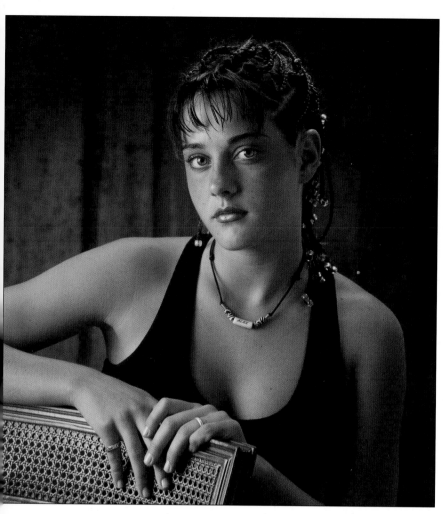

image 3

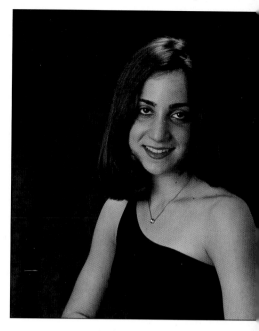

image 4

Another generalization is that the best feet positions for men and women are fundamentally different, unless they are used for special effect. Males can present feet positions that are wide-based and appear to support a pose, while females need their feet to be placed so that there is a tapering as you follow the lines from the waist to the ankles. However, we will see that frequently, especially in fashion and high-school senior portraits, young women in jeans and other casual wear are presented in nontraditional poses that are acceptable since the images are made in the mode of youthful protest.

2. Body Language

O ften, images are created that are simply ugly, despite the fact that the subjects in the portrait are attractive or even beautiful. You will see images in which the photographer did an outstanding job in lighting a beautiful face and used a flattering head position but was obviously so consumed by the beauty in front of him that he overlooked the fact that arms and legs, and perhaps the angle of view of the subject's figure, were less than flattering—or worse.

The main cause of such portraits is that all the elements are not considered as a whole and are allowed to simply fall where they may. Yet, when these elements are considered as a complete package, the subject will respond better, and the overall composition will become more attractive. While body language can make or break a portrait, it is important to first construct the basis of the pose, then to use body language to strengthen the presentation.

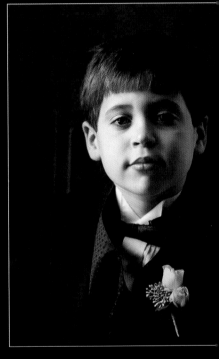

image 5

COMMUNICATION

Body language is very important as it helps to convey much information about the subject to the viewer. Our hands, arms, legs, and head positions are all elements we use to communicate. A good exercise in understanding body language is to observe people engaged in conversation. Watch how these persons physically communicate as they speak. Observe the hand movements, the positions of feet, and the way people present themselves to those they are conversing with. Try to mentally freeze-frame images of them as you would see them in your camera. You will see both unflattering and flattering images in rapid sequence.

PERCEPTION

In example 5, there is no doubt about the attitude of the ring bearer. There is clearly a message of pride and self-importance in his eyes and his head position. The moment seems real, and it could well have been ruined had

he been asked to lower his head and present a more normal portrait angle. To do so would have eliminated the inherent message.

In example 6, the young woman's shoulder angle to the camera, together with her head slightly turned toward her left shoulder, suggests sex appeal and an allure to the male viewer. It is a soft and sensual pose and tells us something about her personality. In example 7, the same model changes her head angle, dipping her chin and raising her eyes to present a more playful but still provocative image.

These examples give us clues as to how we need to pose our subjects in order to ensure they are perceived as they—or we—wish. We need to know something about whom we are portraying or what the portrait is to imply. The pose we allow in our images will be linked to the expression because we cannot create a portrait by only considering one of these important elements.

When you review the posing recommendations discussed in this book, bear in mind that the body language of our subjects is as important as their expression. Also remember that even when we are creating a head-and-shoulders portrait, the way we pose our subject has an impact on the expression we capture. If legs, hands, and arms are not placed correctly, then the expression may not

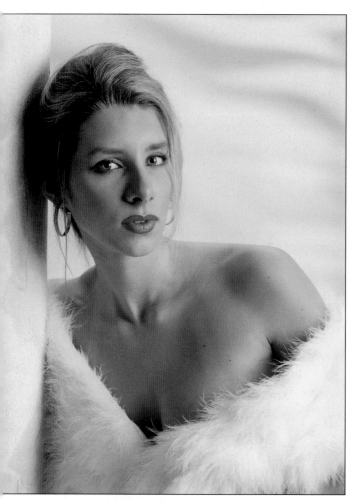

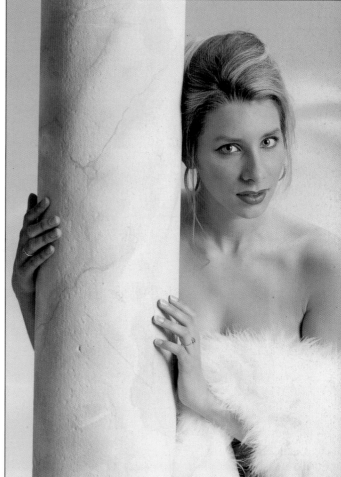

image 6 image 7

be what is most desired. In other words, the pose is as much about the impression the portrait presents as just the facial expression alone. Body language is about communication as much as is the facial expression. They cannot and should not be separated.

There are instances where a pose that might be awkward or slightly uncomfortable will look great in the final portrait. By positioning the subject in a pose that feels awkward, we are making him or her much more conscious of their body than they otherwise would be. As a result, getting a good expression will require us to rely much more on our verbal communication. Such a pose is frequently used in glamour portraits.

THE POSE IS AS MUCH ABOUT THE IMPRESSION THE PORTRAIT PRESENTS AS JUST THE FACIAL EXPRESSION ALONE.

3. *Head Poses*

T o a degree, we have covered head poses while considering posing the total figure, but head-and-shoulders poses have a dramatic effect on the expression and depiction of the subject's personality.

Each time we change the angle of a subject's head, the expression will change. Humans express themselves not just with voice but also with body language. We wave our hands and arms and move our feet in order to emphasize what it is we have to say. But nothing more clearly emphasizes our message than the way we use our facial expressions, which, again, includes the angle of our head.

In each of the images in examples 8–12, our subject's body was positioned very similarly in relation to the camera, but we had her progressively change her head position. When I created this sequence, I did not communicate anything in particular to the subject so as not to influence her expression. My aim in this sequence was to demonstrate that head positions change expressions. Note that I had her shoulders turned approximately 15 degrees away from the plane of the camera, which in effect locked her into an inescapable pose. In example 8, her head appears vertically square to the camera. The expression is passive, almost bored. In example 9, because her head is slightly tilted, her expression has a hint of curiosity. In example 10, her head is tilted a little more, and the expression of curiosity is more pronounced.

In example 11, her position appears reversed, and the head was allowed to fall in the same line as the shoulders. This is a head position that will normally evoke either a bored expression or one of melancholy. In example 12, by having her tilt both her head and her shoulder toward the camera, we achieved a more interested expression.

Sometimes what may appear to be a good idea will not work, and this is illustrated in example 13. In this example, the young lady is clearly uncomfortable with her relationship to the camera. In effect, what we did by positioning her too sideways to the camera was make it a little awkward for

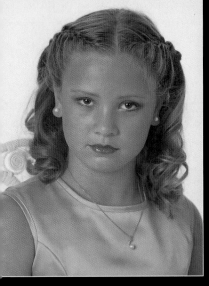

image 8

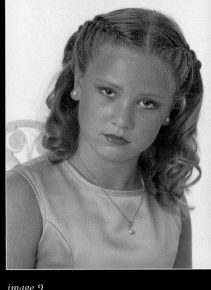

image 9

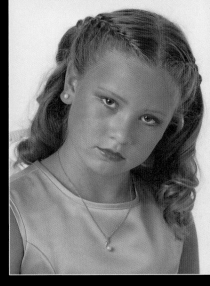

image 10

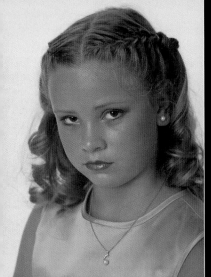

image 11

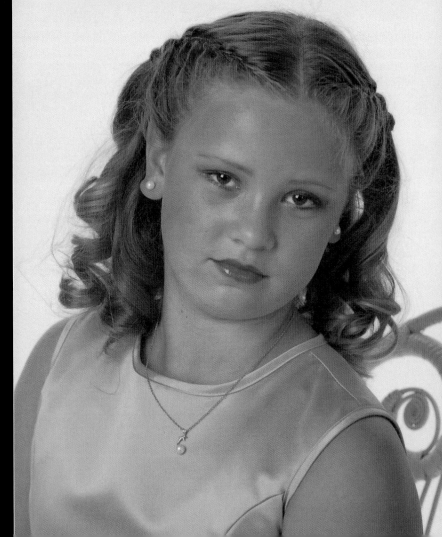

her to communicate with us. First, in order to communicate with us, she tipped her head a little back toward her left shoulder. As a result, we see a narrow view of the shoulders. Unless we have good reason to pose a subject this way, we should avoid doing so. Instead, in example 14, we had her turn her shoulders to the camera at a 15-degree angle. She then had a more comfortable relationship with the photographer, and this shows in her smile. The tilt of her head in this image is very subtle, and that is why she has what could be described as a nice, natural expression.

image 13

image 14

image 15

image 16

In example 15, our subject is shown in a position similar to that of the subject in example 14, but we have evoked a completely different expression by having the subject accentuate the tilt of her head and slightly dip her chin. This created an appealing, sensual look that was further enhanced by the lighting pattern, which added a little mystique to the expression.

In both the two previous examples, the subject's head is tipped toward the far shoulder, which traditionally has been regarded as a masculine head pose. In example 16, we show a typical teen or high-school senior head pose. The young woman leaned on her elbow so that her shoulder became a form of prop and she turned and tipped her head toward her near shoul-

der. This is an adaptation of the "submissive" head position. In this portrait, she is clearly comfortable and was clearly enjoying the communication with the photographer. The image shows a winning smile, but the view of her shoulder is somewhat awkward and not flattering. Normally I would not recommend this pose in a close-up portrait. This would look much better if we were able to see her complete arm so that there would not be so much emphasis on the shoulder.

We'll now turn our attention to some head poses typically used when working with male portrait clients. The first, example 17, is a simple head-and-shoulder portrait of a groom. Note that he is positioned 10 degrees away from the camera so that he is not facing us square on. This allows him to comfortably face the camera with a relaxed smile.

Example 18 is a portrait of a chef in his restaurant that shows him resting his elbows on both a table and the arm of a chair. Even though he was virtually square to camera, because he was resting in a typical male position

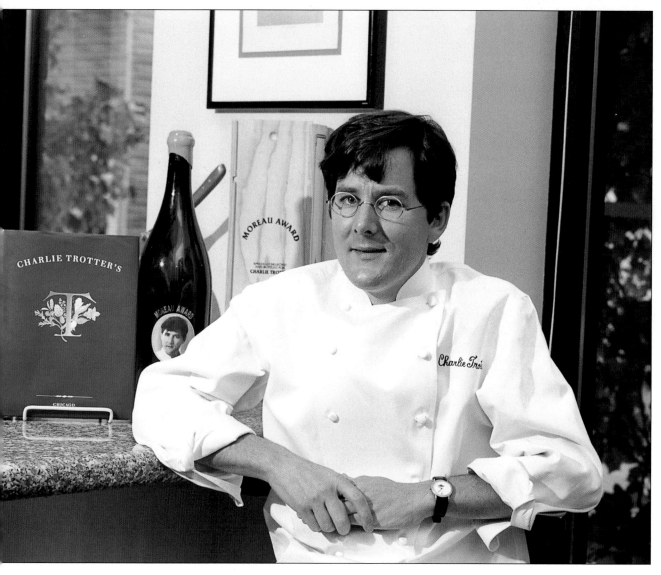

image 19

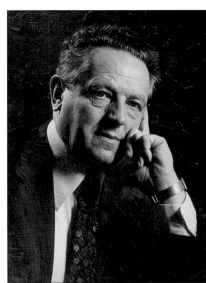

image 20

·image 21

he appears comfortable in his relationship with the camera. Remember, men are most comfortable when they are holding an object or leaning or resting their arms and hands on something solid.

In example 19, world-renowned photographer John Howell is shown resting his left arm on the arm of a chair. His hands appear relaxed, with his right hand resting on his right thigh. Note how his left hand was pulled back slightly toward him, creating a nice compositional line that follows his shirt and tie.

In the strong contemplative pose shown in example 20, the subject's left hand emphasizes his obvious strength of character. The pose, combined

with a more dramatic lighting pattern and the slightly lower perspective of the camera, adds to the power of the portrait.

In example 21, the subject was posed for a softer impression that better reflected his personality. Though not shown, both elbows rested on a table in front of him as he looked up slightly toward the camera with a questioning expression.

Example 22 shows a high-school senior with a strong self-image. His right elbow rested on a table and his chin rested gently on his loose fist with his body posed at a 45-degree angle to the camera. It is a much more youthful pose that presents fresh perspective as he turns his face toward the camera.

IT IS A MUCH MORE YOUTHFUL POSE THAT

PRESENTS FRESH PERSPECTIVE AS HE

TURNS HIS FACE TOWARD THE CAMERA.

image 22

4. Hands and Arms

Probably the most difficult skill to acquire is that of posing hands and arms, especially when the arms are uncovered. Of the countless images that I have reviewed in all kinds of media, in print competition, studio windows, and portrait and wedding exhibitions, the most common flaw in the composition is the placement of hands and arms. When judging prints, I have found that one of the most irritating things is poor posing of the hands and arms—and these imperfections have caused me to deduct points. Many images would have been significantly enhanced if these flaws had been eliminated from the composition.

There are two very important rules when working with hands. First, avoid showing the back of the hand, especially with female subjects. Second, avoid having the hands pointing directly toward the camera. Our aim is to present both arms and hands as simple, elegant, and slim lines. We do this by presenting both sideways to the camera. The exception to this rule is with male poses. In many male poses, we can show hands in a way that emphasizes the strength of the subjects.

No matter how beautiful a subject's hand, when the back of the hand is facing the camera, it will never be seen at its best and may well appear ungainly. In example 23, we see the back of the subject's hands, and the arms are foreshortened because they are projected toward the camera.

image 23 image 24 image 25

image 27

Additionally, the knuckles are emphasized to the viewer. This is not an elegant angle. In example 24, we made an improvement by having the arms running across the plane of the camera, and the hands present a more slim line and appear longer. In example 25, we overemphasized the line, creating an unnecessary emphasis on the hands.

The same elements are examined in examples 26 and 27. In 26, the young lady presents her hands in a natural manner and is not aware of how they appear to the camera. We improve their position in 27, but because the fingers of the lower hand do not fall below the line of the bench, the side view is emphasized; this is something else to avoid when practical.

Example 28 presents a much better line, and the lovely hands appear significantly more attractive. The model in this image is very pretty; she has lovely hands and arms, and there is great temptation to exploit them in our portraits. It was suggested that she rest her chin on her hand as she might do in certain situations, and in example 29 she did just that. But notice how she placed her other hand. It appears too passive and the pose shows the

image 28

image 29

image 30

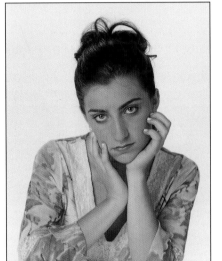

image 31

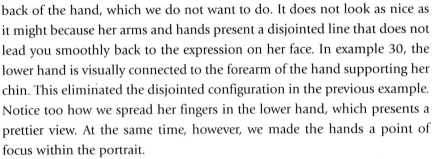

image 32

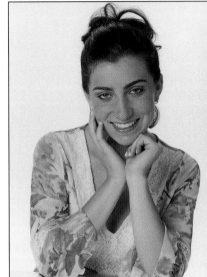

image 33

back of the hand, which we do not want to do. It does not look as nice as it might because her arms and hands present a disjointed line that does not lead you smoothly back to the expression on her face. In example 30, the lower hand is visually connected to the forearm of the hand supporting her chin. This eliminated the disjointed configuration in the previous example. Notice too how we spread her fingers in the lower hand, which presents a prettier view. At the same time, however, we made the hands a point of focus within the portrait.

Example 31 presents a different position for the second hand, which reduces the focus on her hands and also makes a simpler leading line toward her face, the main element of the portrait.

In example 32, we asked the subject to use both hands to support her chin. Note how her left hand attracts attention. This is because it is on the

shadow side of her face, making the light tones of skin stand out in contrast against the deeper shadows, and her fingers form a less than desirable pattern. We immediately corrected this problem, as shown in example 33. Note that we have created a gentle fist-like pattern and have softened the pattern of her other hand by slightly curving the fingers of her right hand.

Photographing the bare arms of a light-skinned subject is always challenging because the brighter skin tones stand out whether in high or low key—especially if the subject is wearing dark clothing. In example 34, although we created a pleasant triangular pose, both hands present the kind of pattern that is not at all flattering. It is extremely difficult to create a pleasant hand pose when one is placed directly on top of the other. It is better to make an adjustment in the pose that allows us to create a more relaxed feel in the portrait. In example 35, one hand is on top of the other, but we have used a different angle so the hands lay in a more simple style. The flow of this pose permits us to get away with a style that in other poses would be less attractive.

As we are always seeking to make our female subjects look elegant, we can experiment with arm and hand poses when we are presented with such an opportunity. The folded-arm pose for the female requires us not to hide

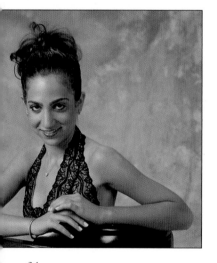

image 34

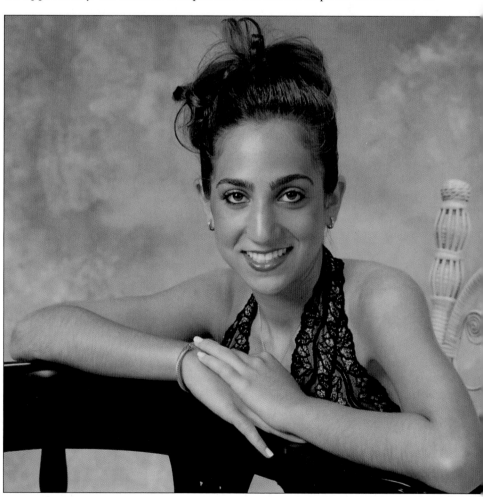

image 35

any part of the hand or arm yet show them as attractive and delicate. In example 36, you will note that the arms are posed to create a circular pattern with the subject's bare shoulders. This leads us to her beautiful smile. If you ask your subject to fold her arms, she will normally have one of her hands, if not both, tucked under her arms so that one or both wrists appear(s) handless. In our example, note how we have her hands visible and delicately arranged. Note the spread of the fingers so as not to create a solid mass of skin tones. Once we have made a subject aware of this more

delicate style, she will readily create the pose without further instruction. The same pose with a male subject will not be appropriate; however he folds his arms will normally work quite well.

In example 37, we see the same arm and hand pose but with a different mood and presentation. In this example, the subject presents her body frame facing the camera. Her shoulder angle tilts slightly, but her head is almost profile to the plane of the camera. The effect is dramatically different. There is a motion to the portrait that is not seen in example 36. In example 38, we see the same posing style but

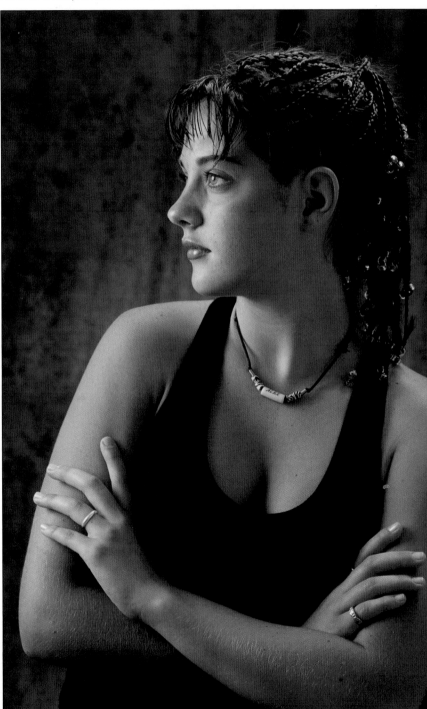

image 36

image 37

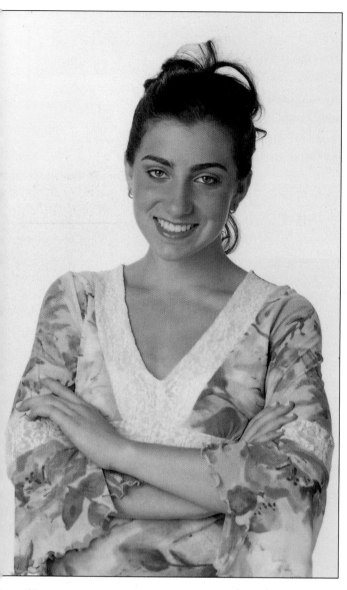

image 39

with a subject with light-colored clothing covering her arms. Note how, in this example, the subject's hands are much less obvious and gently blend into the pose.

■ BREAKING THE RULES

Now that we have established some basic rules, how may we break them? In example 39, a vintage-style portrait, the young woman's hands are placed at the bottom of the image, one over the other, with one in a gentle fist-like pose. The hands in this image are deliberately used to create a dynamic that would be missing if they were not shown. Additionally, the hands were slightly vignetted, simply to soften their appearance. We have broken the rules, but the result is very effective.

In example 40, the pose deliberately challenges conventional posing techniques. Both hands are posed in exactly the style that we have previously said should *not* be used. Because the idea was to be provocative, all the elements in the total pose defy the rules—yet, because it is not carelessly done, it is effective. Notice how the choice of attire also reflects this "rule-breaking" concept. This is not a conventional portrait; it is a teenage expression of style. If we had posed her hands more traditionally, then the portrait

would suggest we had our subject inappropriately attired, and the image would not have the same impact.

In example 41, the portrait defies two rules that we normally will not wish to break. First, the back of the hand, which slightly shows the knuckle, is facing the camera. Second, the posing draws direct attention to her arm. At the same time, though, the overall pose has an interesting line that connects the lovely profile to the flower that she is focusing on. This is reasonably effective because the posing of both the hand and the arm is deliberately formed for its own purpose.

In example 42, we were exceptionally creative with the positioning of the young woman's hands and arms. The first rule broken is that the pose shows the back of the hand as it rests on her arm. However, in this creative

THE OVERALL POSE HAS AN INTERESTING LINE THAT CONNECTS THE LOVELY PROFILE TO THE FLOWER.

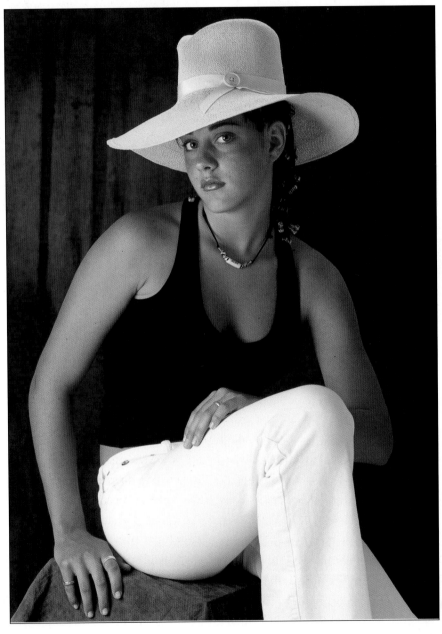

image 40

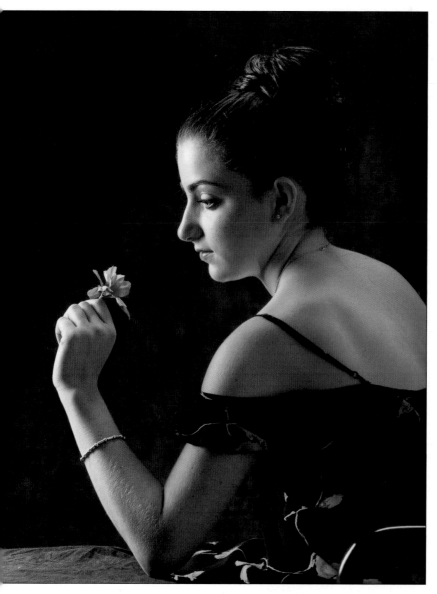

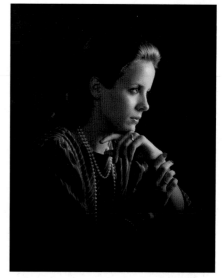

image 42

pose, the delicate hand poses lead directly to her beautiful profile. Additionally, the lighting has a direct impact on the hand and arm pose and how it is presented to the camera. The fingers on each hand were deliberately refined for the best of results. This is an artistic hand pose that is possible if the subject has beautiful hands.

In example 43, we attempted a different approach to placing the hands and arms in order to create a more comfortable portrait. The basic idea of creating leading lines toward the young lady's face was less than effective because the angle of view is slightly oblique to the camera and presents a less than attractive view of the elbow at the bottom right of the portrait. Additionally, because of this angle to the camera, we made the back of her hand too open toward the camera and thereby have emphasized the knuckles. Also, her right hand and arm appear slightly foreshortened. This view of a forearm is sometimes referred to as a "chicken leg" pose. These flaws cause the pose to break down.

In example 44, the camera was moved to confront the subject square on. As a result, we have cropped off a little of the elbow, something I normally would not advocate. The dramatic difference is that the lines in the composition work much more effectively—the posing of her left hand is acceptable, and the positioning of her right arm made it appear sleeker and more attractive. The issue here is that we have broken the rules but have done so deliberately, for effect.

image 41

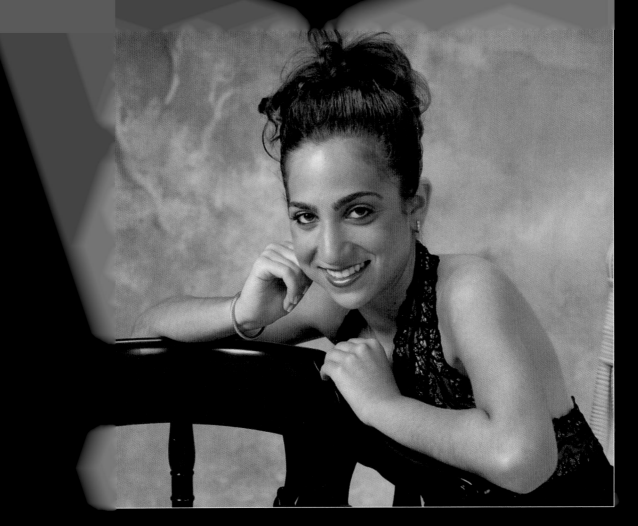

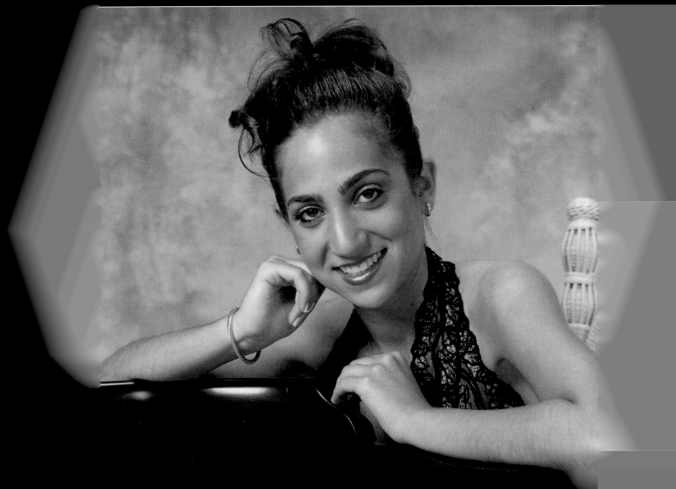

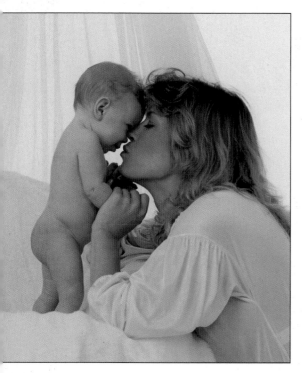

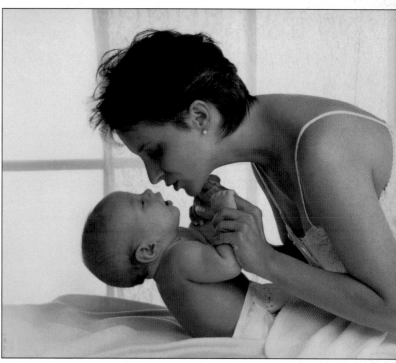

image 45

image 46

While we endeavor to create simple and delicate lines in a mother-and-baby portrait, there are some situations that will not allow us to follow the rules. Most portraits we make of mother and baby will be in profile so as to demonstrate the special relationship between them. Additionally, the mother will often need to hold the baby's hands, and the back of her hands will be shown to the camera, as seen in example 45. But because of the power of the image, this flaw is readily accepted. The same flaws are shown in example 46, but in this latter example, the flaw appears worse because there is a cluster of hands and fingers within a very small and obvious area of the portrait. However, this flaw is also acceptable because the mom's hands and fingers play an important part in depicting the emotion the portrait implies.

5. Feet Positions

A key to good posing is the proper positioning of the feet. How the feet are placed dictates how the rest of the body presents itself to the camera. This is true for both sitting and standing poses.

We first look at how the feet are positioned in standing poses. In diagram 1, we have a bird's-eye view of the feet positions of one female and one male. These positions allow both to be able to look at each other and at the camera. Note that the female has the foot nearest to the camera positioned with her heel close to the instep of her back foot, with her toes turned almost directly toward the camera. The male has his feet in what would be described as a typical and comfortable "guy" position.

In diagram 2, we build on the first diagram by adding two additional males and two additional females. Posing six people presents a problem because we need to reverse the angle of some of the subjects so as not to present all the figures facing the same direction. You will note that the feet are positioned correctly, even though some subjects now face the opposite direction. Also note that the toe lines are kept tightly under control. If we allow any of the subjects to break the toe line, the view from the camera position will look untidy, and this will spoil the group's pose.

In examples 47–49, we show how we will address the foot positions of two females. Note that in example 47, the young lady at the right has both feet together and aimed at the camera, while the other has a more pleasant presentation, though not yet as best it might be. In both instances, we might describe the foot positions as "duck's feet." In example 48, we moved the left-hand figure's front foot in the position advocated in diagram 1, and the right-hand figure's right foot was turned away from the plane of the camera. This is a distinct improvement, but we are not quite there yet. In example 49, note the new positions of both subjects. In both cases, the front foot was moved to partially cover our view of the back foot, thereby creating a more tapered line from top to bottom. This is the most acceptable standing position for the female subjects.

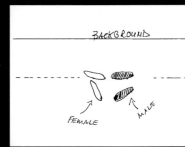

diagram 1

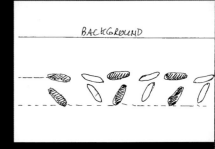

diagram 2

image 47

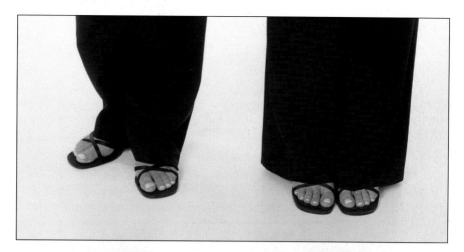

image 48

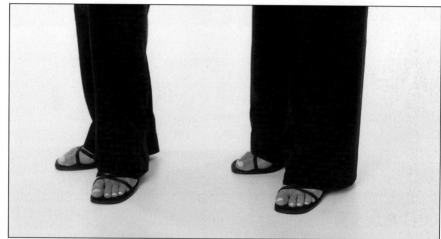

image 49

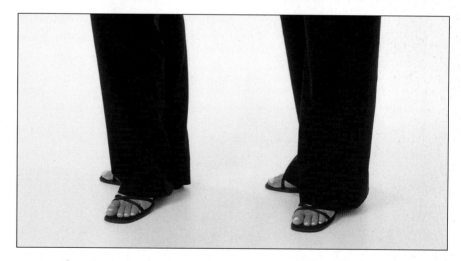

Now for a look at the feet positions used for seated subjects. Basically, the principles are the same. In example 50, we come back to the two young ladies discussed earlier. Note that the subject at the right is positioned defensively, while the other young lady has a more "posed" position. In example 51, both subjects have almost identical positions, making for a much more ladylike presentation. The one flaw is that their knees would be better presented if they were closed.

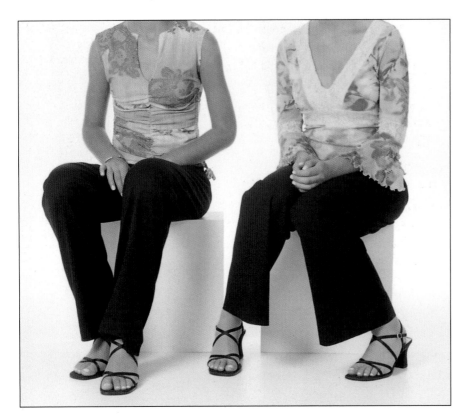

image 50

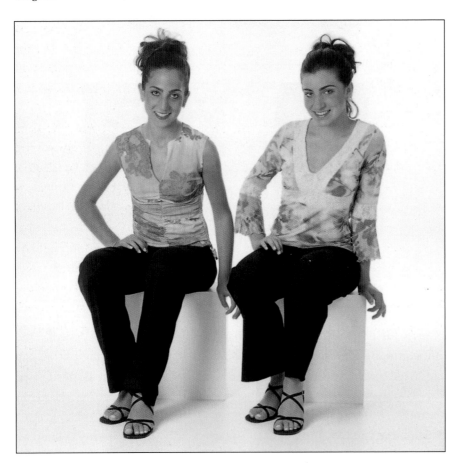

image 51

image 53

image 54

In examples 52–54, we progressively refine a duck's-feet pose into an acceptable, tapered look. Note that we moved the back foot toward the subject in example 53, which improved the view but still leaves much to be desired. In example 54, we achieved a much more pleasant view of a tapered-feet pose.

WE NEED TO HAVE THE LEGS OF OUR FEMALE SUBJECTS LOOK AS LONG AND AS SLIM AS POSSIBLE.

In seated poses, we need to have the legs of our female subjects look as long and as slim as possible and avoid views that present a foreshortened appearance. In example 55, note that the two young ladies were slightly turned toward a three-quarter view, allowing us to best present the legs as described above. Note in particular how the young lady on the left pulled her feet closer together than the other to present a slightly more elegant pose. Additionally, because she was turned slightly more in profile to the camera, her legs look a little longer and are better presented. At the same time, the foot positions of the right-hand subject draw a little more attention due to the fact that her feet are farther apart. In example 56, we reversed the positions of the young ladies, positioning their feet similarly to the way they appear in example 55. There is a subtle difference, though: note that the subject on the left has now brought her feet closer together, resulting in a much more attractive, tapered look.

What we have not identified so far is that in both examples, 55 and 56, the young lady on the right has her right knee breaking the tapered look of the other leg, and the result is less pleasant than we would prefer.

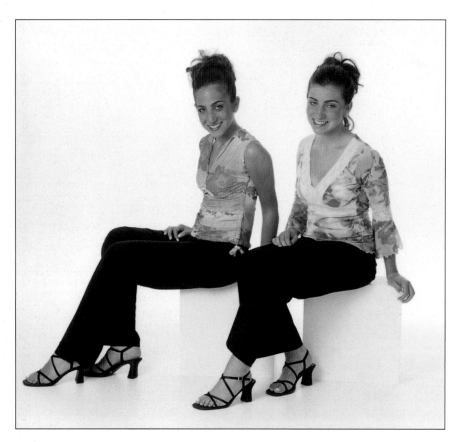

image 55

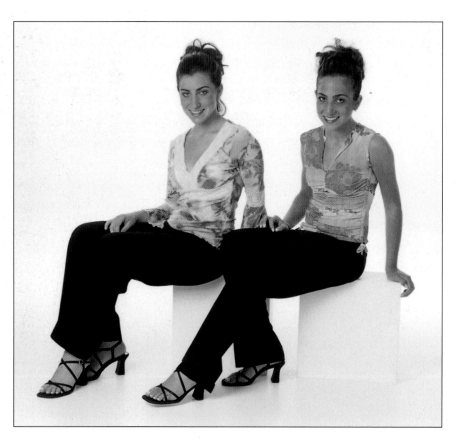

image 56

6. Standing Poses

T here are some notable differences in posing men versus women. We'll take a look at some key strategies for a successful pose here.

MEN

Posing men is usually much easier than posing women. In some senses, almost any pose that a male strikes is likely to be acceptable, provided we adhere to the basic principles we have previously discussed and that the hands and arms are well positioned. So, with this in mind, we should seek to position men in a way that is appealing and demonstrates masculinity.

A note that I have always made in a humorous vein is that men need to be holding on to something—preferably a woman. It is well noted that when you see a young couple walking together, it is almost always the male who has his arm around the shoulder of the female, as if he needs the support.

Men have a natural need to be doing something with their hands, and when they are not directed otherwise, they immediately go to the dreaded "fig leaf" pose, where they clasp their hands together in front of their pelvic region. This should always be avoided. Hands in pockets, thumbs hooked on belt, hands grasping a railing, or arms folded are all much more masculine alternatives that present strength. Men also like to lean onto almost anything that is readily available, and the opportunity to put a foot up onto a rock, step, or other prop will rarely be passed up. Unless they are trained in dance or modeling, men are much less aware of their physical demeanor than are women, so we need to help them a little by refining their presentation. Like most people having their portrait made, whether in the studio or at a wedding, men feel a little awkward and self-conscious. In cases like these, the photographer must play the role of director.

In examples 57–59, we start with very basic poses. In 57, the young man presents himself to the camera in a three-quarter view. It is pleasant but not

UNLESS THEY ARE TRAINED IN DANCE OR MODELING, MEN ARE LESS AWARE OF THEIR PHYSICAL DEMEANOR THAN ARE WOMEN.

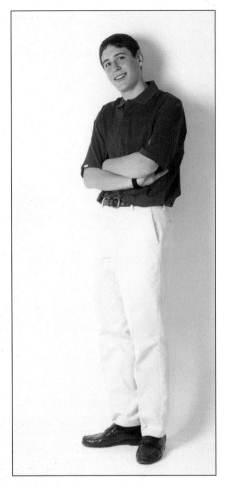

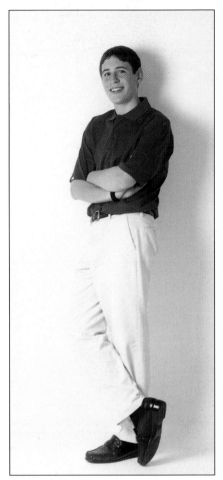

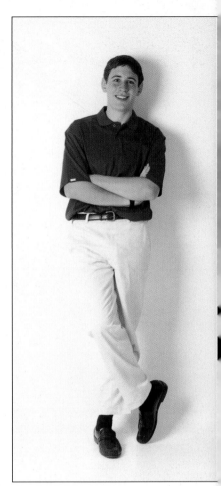

image 57 *image 58* *image 59*

nearly as relaxed as in 58, where he kicks his right foot over his left while he leans against the wall. We present an even stronger look in 59 by turning him square to the camera, arms still folded, and with his foot kicked over the other leg. The view is a wider look that offers more physical presence.

In examples 60–65, we demonstrate a series of presentable male poses. Note that the available railing and pillars are exploited in each. Hands are in pockets, fingers are hooked into a belt, or arms are folded, and we have one view with a foot up on a bench. These are all typical male poses, though we have either directed them or refined them to the best advantage. What is most important is that, in each, the subject looks comfortable as well as masculine.

Note also that we do not allow the hands to be totally hidden in the pockets; instead, we have just the thumbs hooked into the trouser pockets.

In most situations, we can simply ask a male to take a natural and comfortable position against a wall or pillar and see what happens. We may well find that all we need to do is refine the pose. Often, we can simply demonstrate what we want him to do. This is the best approach at weddings, where

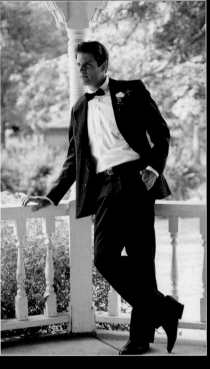

image 60

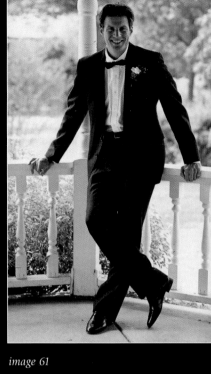

image 61

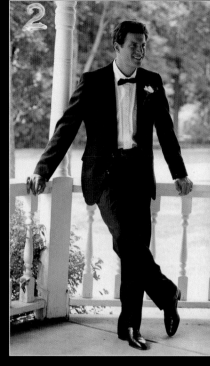

image 62

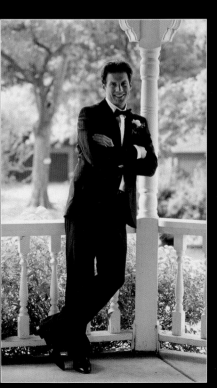

image 63

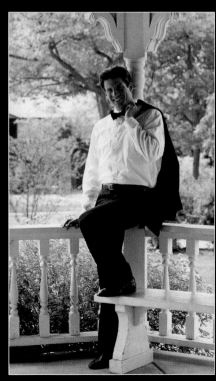

image 64

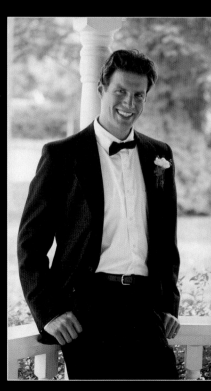

image 65

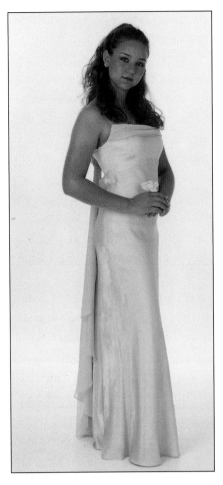

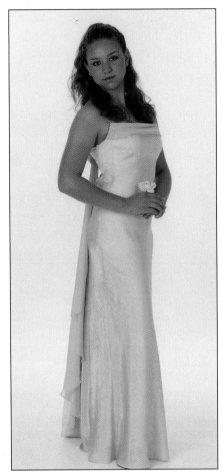

image 66 *image 67*

WHEN WE POSE OUR FEMALE SUBJECTS, WE

TYPICALLY NEED TO SHOW THEM LOOKING

AS SLIM AND ELEGANT AS POSSIBLE.

time is of the essence. In fact, my personal means of getting what I want is to demonstrate the pose, even for my female subjects (though obviously I cannot look as lovely as my female subjects, and I excuse myself for this lack of charm).

■ WOMEN

Women are usually much more aware of their physical presence than are men and tend to offer themselves to the camera in what they think is the most attractive position. However, this rarely results in the ideal pose for the full-length portrait.

When we pose our female subjects, we typically need to show them looking as slim and elegant as possible. This normally will require us to show her at an angle that is oblique to the camera, not square on, since a pose that is square-on to the camera is, in most cases, unflattering. The exception to this rule is a portrait in which she seeks to present a demonstrative impression. Alternatively, she may do so because she is blessed with a very well-formed figure and simply wants the viewer to appreciate it.

In example 66, we posed the young woman in a three-quarter position to the camera, and while we cannot see her feet, we followed the advice in chapter 5. To create this example, we asked her to place her weight on her

back foot and to let her front leg relax, and you can see the break in the line of her leg. Note that we placed her arms so that her forearm gently rests at her hip. This presents a nice gentle line that runs downward and so avoids the undesirable straight-across line that we too often see in portraits. As a reliable guide with regard to the placement of female arms, note that the wrist, or the area just above the wrist, should be placed at the subject's hip. This will ensure that her arms create a nice curved line rather than a horizontal line across the figure. This is particularly valid when posing a bride and her bouquet.

Note too that in example 66, the subject's hands run across her tummy, and we endeavored to present them as sideways to the camera as possible. A flower was used to allow the hands to join together. Also note that her head tilts away from her near shoulder. This is a stronger female impression and creates a very gentle S curve.

In example 67, we asked the young woman to tip her head toward her near shoulder in order to create the more traditional female head pose. In this example, the young woman looks most attractive, and the head position emphasizes the S curve.

In the old days, women always wore dresses and skirts, rarely trousers. Now women wear slacks and jeans that would not have been acceptable fifty years ago. This allows them to strike poses that are similar to those of men, though obviously with a lot more femininity and charm. However, there are some poses that are not recommended for our portraits.

Examples 68–73 (following page) show a sequence of poses with the young lady wearing slacks. In example 68, note how she is virtually square to the camera. While still pleasant, she is a little stiffly posed. Her arms are nicely placed to present a soft line around her upper body, but there is a slightly disjointed look to the image. We immediately made a slight improvement in example 69 by turning her very slightly and using her right hip to emphasize her pretty figure. Note that in both of these images, we have broken the rules about positioning feet. Consequently, the pose is less feminine than it could be. In example 70, we reverted to the rules and placed her feet as recommended. Even though she is almost square to the camera, the slight turn of her hips away from us creates a very soft and feminine line. The S curve is again maintained.

In example 71, we used the cross-over foot technique used often with males, but with a distinct difference: the subject's feet were kept close together and she was turned slightly in the opposite direction, with her shoulders tipped slightly toward her left. This presented a desirable curve. But in example 72, we pushed the envelope a little with a more demonstrative expression and with the feet angled a little away to the left, making the curve more obvious. In example 73, we simply built on what was done in 72, except we presented her hips a little bit square to camera. Note, however, that the S curve is still there.

THE WRIST, OR THE AREA JUST ABOVE THE

WRIST, SHOULD BE PLACED AT

THE SUBJECT'S HIP.

image 68

image 69

image 70

image 71

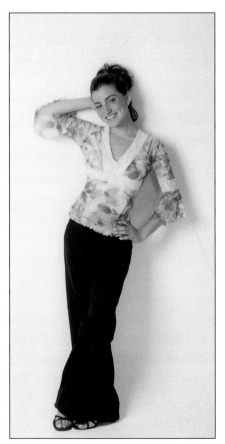

image 72

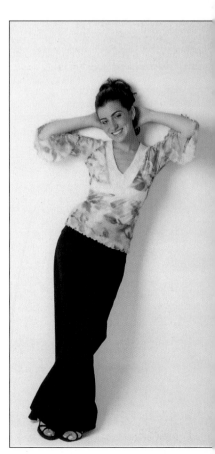

image 73

7. Seated Poses

I n this chapter, we'll look at some posing strategies that you can use to ensure flattering images of your seated male and female subjects.

MEN

Men normally present themselves in a casual pose that often needs only to be refined. In example 74, we show a very acceptable male pose. Note again that we have avoided the square-on to the camera position and have instead positioned the young man in a three-quarter view. We had him rest his elbows on his knees so that he is presented in a proactive attitude that is much more interesting than if he were sitting upright. Note that his hands

image 74

image 75

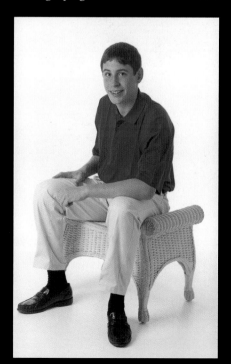

image 76

are together but not knotted, which is one of the first things that most men will do with their hands. This presents a very pleasant pose.

In examples 75 and 76, the same young man is shown in an even more proactive pose. The difference is that his right arm is drawn back and onto his knee, which changed his attitude toward the camera. The difference

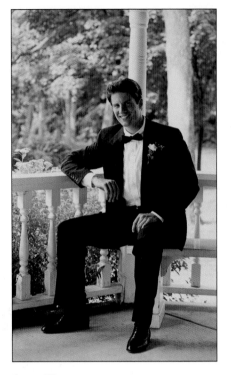

image 77

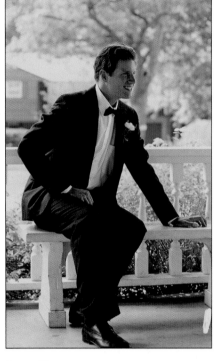

image 78

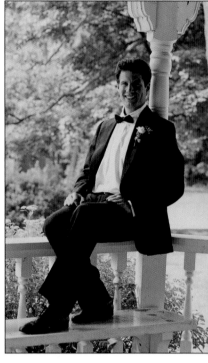

image 79

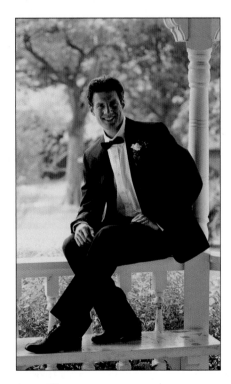

image 80

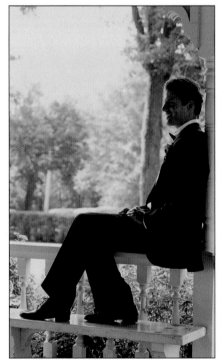

image 81

between examples 75 and 76 is the posing of his left hand. I prefer the gentle fist in example 76, as I am not a fan of passive male hand poses.

The following sequence of five poses demonstrates how easy it is to obtain a relaxed male pose. We used the same bench for each pose. In this case, each pose can flow relatively easily from one to the other. All we ask is that the subject steps up onto the bench for three of the poses.

Example 77 is a natural pose for almost all men, but when the subject first sits down, his hands and arms will probably not be placed as we have shown them in this example. Note too that we have the camera at a slight angle so as not to show his feet as toeing a straight line. Note that his right arm is coming across his body and not pointing at the camera, while his left hand rests upon his upper thigh. Both hands are positioned in a relaxed manner. This is a very basic pose and can be exploited to create other interesting presentations.

In example 78, we moved the subject to the opposite end of the bench and turned him so that he appears to be communicating with another person. This could be a bride if this were a wedding portrait. Note again how we placed his feet and hands in order to create interesting leading lines that take us back to his face.

In example 79, the subject was placed on a bench so he could lean against the pillar in a relaxed, masculine pose. Note that the placement of his feet and hands created interesting lines and allowed the subject to project his smile to the camera in a natural way.

In example 80, we made a very simple adjustment that caused the subject to communicate positively with the camera. All we did was have him lean toward his right knee.

To produce the results shown in example 81, we simply moved the camera position to create a profile image from the position the subject was in for example 79, then had him lean back against the pillar again.

■ WOMEN

When a full-length, seated view of a subject is created, we often encounter some problems regarding the way in which the person is presented to the camera. For instance, we need to avoid having the knees of the subject, especially those of the female, directed toward the viewer, since this will cause the knee to appear foreshortened and may well produce a chicken-leg impression. The knee, especially uncovered, never looks good—even those of the loveliest female subject. So in all the examples discussed here, you will not see the knee of a subject aimed at the camera. Even in group compositions (as discussed in chapter 10), we will aim to avoid this posing flaw.

In chapter 6, we discussed how we should pose our subjects' legs, and we again look at this topic when covering seated poses. In example 82, our subject is turned almost full profile to the camera, or at a little less than a three-quarter view. This allows us to present her legs most attractively. Note how

THE PLACEMENT OF HIS FEET AND HANDS CREATED INTERESTING LINES AND ALLOWED THE SUBJECT TO PROJECT HIS SMILE TO THE CAMERA IN A NATURAL WAY.

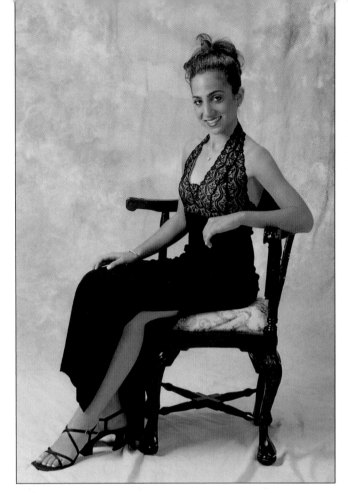

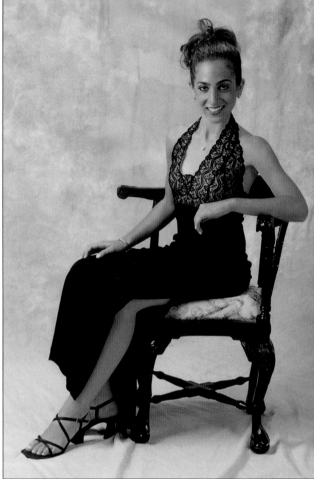

image 82

image 83

her feet were posed with the near foot stretched a little longer than the back foot. The fact that she is displaying bare legs in this position makes her leg look long and sleek. Note too that in this pose she looks a little narrow-shouldered, which creates the illusion that she has a wider waist than she actually does. Now see example 83. In this image, we made a very subtle adjustment by turning her far shoulder a little toward the camera. This widened the view of her shoulders and brought her right arm into view. As a result of these changes, we have narrowed the appearance of her waist by creating a more tapered view.

Note too that her right hand and arm are now presented in a gentle curved position, with her hand resting on her knee. The way her left arm is resting on the chair creates a little too horizontal view, but it works because her shoulders and arms create a kind of circular line that leads us to her lovely smile.

Normally we would not recommend posing a subject with shoulders square to the plane of the camera. The exception to this rule is when we are presenting the subject in either a three-quarter or profile pose. In example 84, you will see how we have broken the rule. Note that her hands are resting together close to her stomach, creating a nice line that leads to her face. The fact that she is looking off to her left makes the square shoulders less obvious; in fact, the shoulders support her head pose.

THE FACT THAT SHE IS DISPLAYING BARE LEGS IN THIS POSITION MAKES HER LEG LOOK LONG AND SLEEK.

In example 85, the young lady is presented in a casual pose that is quite typical of a teenager. She has a denim jacket hooked on her thumb and slung over her left shoulder. Her right hand supports her weight as she leans slightly to our left, creating an interesting angle. The effect of this pose is to present an attitude of interest in what we are doing at the camera position. Note too how she has crossed her right leg over her left. Normally, we would expect to present her with the left over the right, but this pose is much more interesting.

In example 86, the young woman is posed at a slight angle to the camera, shoulders square to the focal plane, but with her knees turned away at about 20 degrees. Again, this pose shows her face in a semi-profile so as to conform to the rule discussed earlier. Note also how her left hand is placed on the side table, creating a leading line through her shoulders to her head.

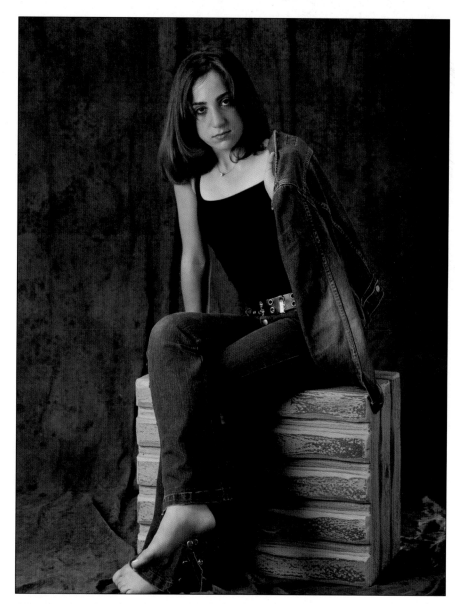

image 84

image 85

image 86

image 87

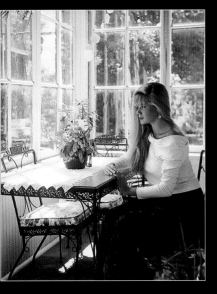

image 88

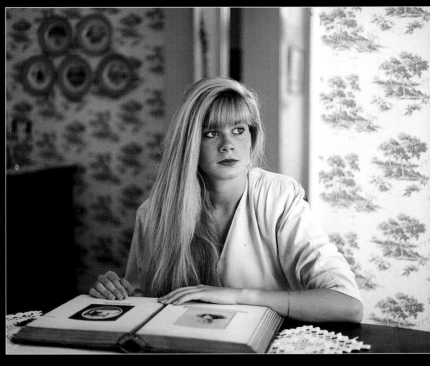

image 89

image 90

Again, note that the positioning of her feet conforms to the rule that was previously established.

In example 87, the same young woman is shown in a full-profile seated pose. Note the placement of her arms and hands. They are resting in very natural positions and do not contradict the concept of the pose. Key to the elegance of this seated pose is the position of her legs and feet, which create a tapered line from her knees to her toes.

In example 88, we show another pose of the same subject, this time seated at a table. Again, this is a profile presentation. The young woman is wearing white, which often causes the subject to look larger than she is in reality. To make her frame look as normal as possible, her left arm is placed so that it runs in a line toward her stomach, while her right hand rests on the table and joins her left.

In example 89, we have a closer view of the subject, one that is much more attractive. This time, we used the lighting to diminish the effect of a lot of white sweater, and the position of her hands help to refine the total portrait. Additionally, we posed her in a slight leaning position so as to create motion in the portrait. The angles we present our subjects in are important because vertical and horizontal lines are most often too static and passive.

One of the most popular props used by photographers is a posing table. In example 90, we pose the young woman at a table with a book as a prop. Note that the camera angle is slightly to the right of the subject's shoulder plane so that her shoulders do not appear square to the camera. At the same time, the subject is looking slightly away to our right and her arms are in harmony with the book. The triangle formed by her arms and shoulders leads us straight to her face.

In example 91, we broke the rules again by having our subject's shoulders virtually squared to the camera. However, we compensated for this by having her left arm centered so as to break up the shoulder line. The position of her right arm also assists in breaking the square line of her shoulders by creating a secondary line that leads us back to a very beautiful expression. The low angle of the camera, which allows us to see under the hat, additionally compensates for breaking the rules, and we have what is a very interesting image.

Though I have indicated that this book really does not cover children's portraiture, one little model will be used to demonstrate ideas on how we may pose female subjects. It is an interesting phenomenon that little girls and adult women often have much in common when we are posing them for portraits. So we thank little Annie for this little sequence of poses. We can, in many instances, use these poses for older, more mature subjects.

Example 92 shows a very relaxed body profile with the subject's head turned toward the camera in a three-quarter pose. The subject's hands and arms are shown in a pleasant pattern, resting nicely in her lap. The pose creates an appealing soft line that starts at her feet and leads to her face. In

THE ANGLES WE PRESENT OUR SUBJECTS IN ARE IMPORTANT BECAUSE VERTICAL AND HORIZONTAL LINES ARE MOST OFTEN TOO STATIC AND PASSIVE.

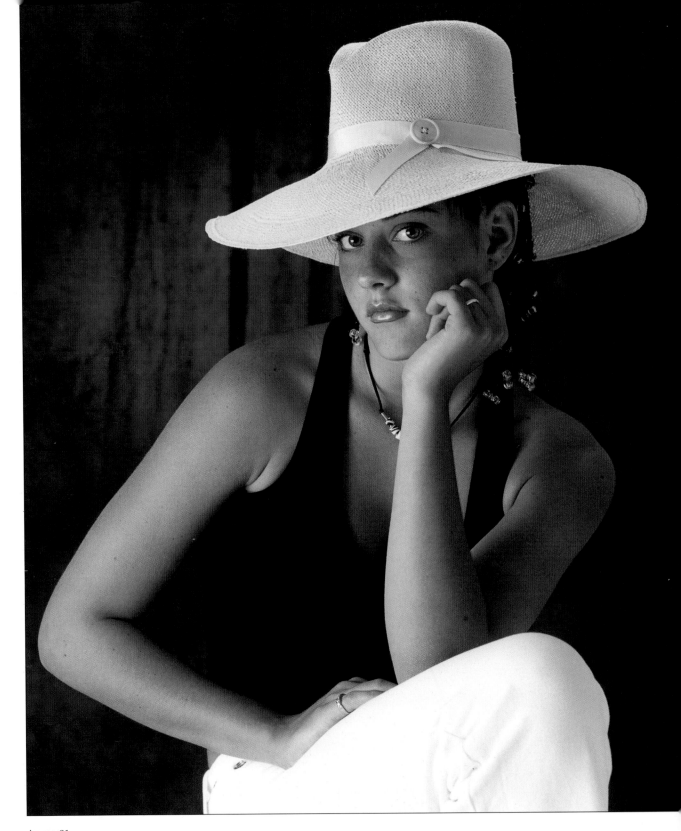

image 91

example 93, we made a very simple adjustment. By bringing her left hand
to the bench slightly behind the line of her back, we created a more dynam-
ic line and caused her head to come into a more challenging position (a
more full-face pose), thereby making a much more interesting impression.
Note, too, that her right hand is moved to her knee, creating a longer line.

WE MADE A VERY SIMPLE ADJUSTMENT

THAT CAUSED HER TO LIFT HER HEAD INTO

A MORE PROACTIVE POSITION AND

RESULTED IN A MORE FORMAL PORTRAIT.

In example 94, we used a box as a seating prop. The girl's right foot was placed on the bench and is hidden by her left leg, which was posed to present a triangular pattern with her toes pointed so as not to have the foot break a nice long line. Her right forearm rests on her left knee with her hand drawn toward her body rather than pointed directly toward the camera, while her left hand supports the pose.

Her head position indicates a slightly playful attitude. In example 95, we made a very simple adjustment that caused her to lift her head into a more proactive position and resulted in a more formal portrait.

image 92

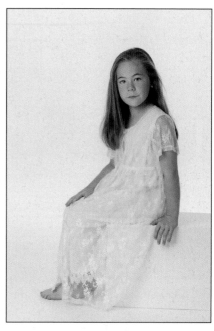

image 93

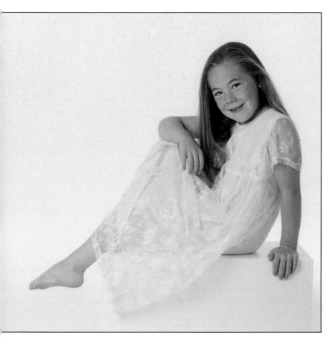

image 94

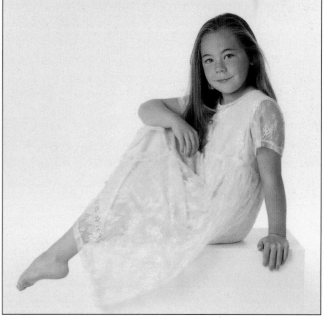

image 95

8. Floor Poses

Posing our subjects on the floor offers many options in both individual and group poses. Many of the poses demonstrated in this chapter apply to both male and female subjects. We always seek to present the subject parallel with the plane of the camera, never with their knees and legs aimed at the camera. When legs and knees are aimed at the camera, they become foreshortened and look stump-like, making even a pretty leg look less than attractive. Even when posing males, we seek not to have the knees aimed at the camera unless the knee is being used as a prop to rest an elbow or hand.

If you are an admirer of pretty legs, you will enjoy the sequence of poses starting with example 96. In this example, the subject is seated on the floor in a natural pose. This is a position she would assume if she were watching TV or chatting with friends in a casual environment. If we were to ask her to sit on the floor without any special instructions, this is a pose she likely would offer. As lovely as she is, this is a bad pose to record in a portrait. Even if we agreed that she has pretty knees, this would not present them in a flattering way. Also, her right arm is too stiff and her left arm is too casual, foreshortening the view of her forearm.

To improve the pose, I asked her to lengthen her legs, and the result is shown in example 97. The pose is better but is far from acceptable because we are still focusing on one of her knees. In this example, we have improved the position of her right arm, but her left is still not where it should be.

In example 98, we significantly improved the overall pose by lengthening her legs and having her kick her left leg over her right, which is an interesting leg pose that is sometimes used in dance images and in modeling shots. However, the way her left arm runs over her hips is too casual, and her upper body appears too flat. Because the overall pose lacks the refinement we seek, the fact that her right arm is very straight is emphasized.

In example 99, the legs' positions are very nice. The leg nearest to the camera is elongated, with a nice bending of the knee. The back leg is drawn

POSING OUR SUBJECTS ON THE FLOOR

OFFERS MANY OPTIONS IN BOTH

INDIVIDUAL AND GROUP POSES.

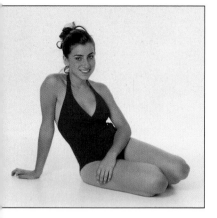

image 96

a little nearer to her to create a nice tapered look. Additionally, we brought her left shoulder around toward the camera, creating a more attractive tapered pattern from the shoulders to her waist. This position also improved the bustline. However, we still needed to improve the left arm position. This we did in example 100. The arm was drawn back to allow her forearm to rest on her back leg, which improved the overall upper-body pose. In example 101, we made further improvement by having her turn her left shoulder a little more toward us and slide her left hand down her left leg to rest it on her knee. Note how this enhanced her bustline and accentuated the impression of an even narrower waistline. This pose is very attractive and would please the most critical of female subjects.

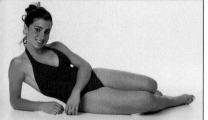

image 97

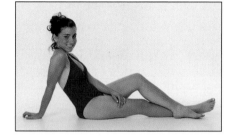

image 98

image 99

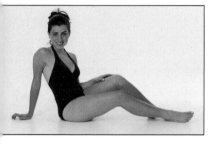

image 100

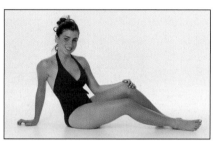

image 101

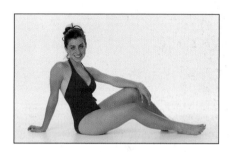

image 102

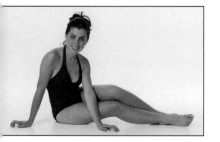

image 103

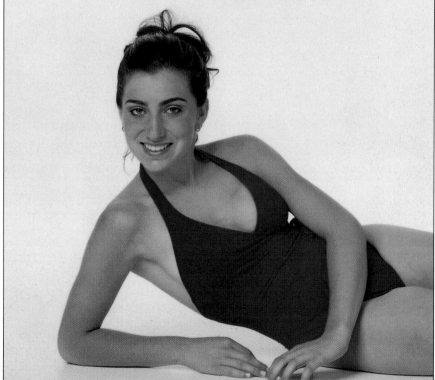

image 104

Example 102 is a more casual version of the same pose. The hand on the knee appears more relaxed, but we lost a little of the glamour of the pose since the left shoulder now retreats a little, breaking down the tapered look we seek to obtain.

In example 103, we bring the left hand across the body and set it on the floor parallel with the subject's right hand. This creates an attractive, even if more relaxed, pose that brings the subject more proactively toward the camera. The triangular design of the arms leads to her lovely smile, while we still retain the attractive leg positions.

In example 104, we attempted something more daring: we closed in on the subject and cropped her legs at midthigh. This is something that must be done with care, as cropping limbs always risks the look of an amputation. In this case, we were able to get away with it, because the focus is on the nice leading lines of her arms and hands, which take us to her smile.

Example 105 shows two pairs of lovely legs at the same time. Note how both subjects were placed so that their shoulders are clearly visible. At the same time, because they are in a staggered position, the subjects' legs look beautifully long. Note too that the toes are pointed in a continuous line with their legs. The front subject's arm is nicely curved too. The primary flaw is that there is a hand extended behind the front subject. We won't make this mistake again.

Example 106 shows a very relaxed and comfortable pose. If the young woman was not wearing slacks, this might be considered unladylike, as the image presents an open-legged view. In this case, however, there is a nice line to the portrait, and her hands and arms are posed to create a circular line with her head and shoulders.

Posing our subjects on their stomach can create some fun and often very pretty images. Example 107 has the young lady posed in a higher position than in example 108. In both poses, the composition leads us to her face.

NOTE HOW BOTH SUBJECTS WERE PLACED SO THAT THEIR SHOULDERS ARE CLEARLY VISIBLE.

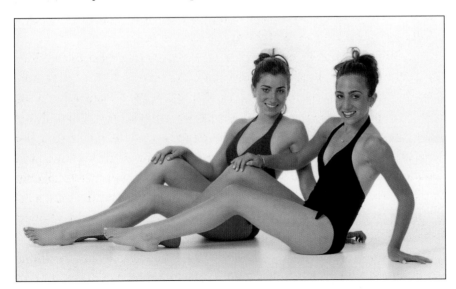

image 105

image 106

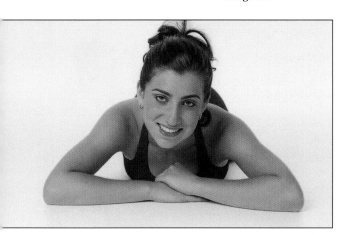

image 107

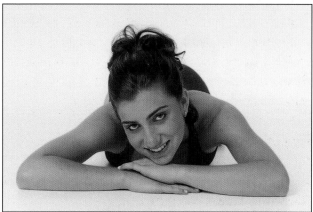

image 108

Positioning our subjects on their tummy in this style requires us to pose the hands and arms in as sleek a manner as possible. The top hand in 107 offers a little too much knuckle, and this is corrected in 108.

We deal with couples in a later chapter, but as we are discussing floor poses now, we can broach the subject with examples 109–12. In example 109, the couple is shown in a fun pose that allows the female to be in the dominant position. This is not a pose that we will use often, but with the right couple it will work. Note that we have connected them by resting her hands on his shoulders and having her head touch his while his hands and arms create the desired circular pattern. His body angle forms a diagonal line that leads to the touching heads, which, because she has her head a little higher in the frame, continues the diagonal line. This pose also allowed us to show the young lady's knees in an obvious way.

In example 110, I asked the couple to sit "Indian style." Their positions are quite natural but not ideal, even though they appear quite happy, and we might sometimes overlook the flaws. In example 111, her hands and

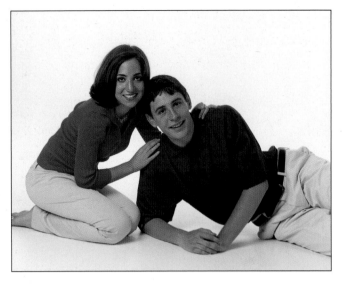

image 109

image 110

image 111

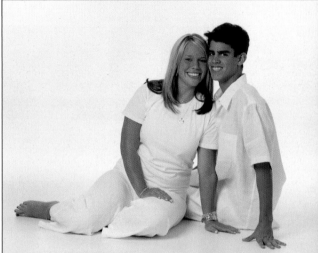

image 112

arms were rearranged according to the rules we have previously discussed. Her elbow was brought onto his leg so as to have her shoulder break the line of his. It brings them together in a very nice pose that implies they are perhaps more than just friends.

The couple shown in example 112 is posed in a different style. Note that he is acting as a prop for her to lean into, and her legs are positioned as was recommended earlier. Her left hand is nicely positioned, and although her left arm is in a vertical line, it supports her position so that she does not have to actually lean on him. There is a triangular composition to the pose, leading from left to right and to the faces of our subjects.

9. Slimming Techniques

When posing female subjects, we will make ourselves popular by making them appear slimmer than they might be. In fact, I cannot recall any female subject who did not like the notion of appearing slimmer than she is, even if she were as slim as a supermodel. Probably 80 percent of women will suggest to us that they are concerned that they will look fat. So, female subjects are posed in a manner that appears to create a "slimmer" view.

In example 113, the young woman was placed at a three-quarter view to the camera and was positioned to face the main light. Her hands and arms are shown in good positions, but because she was facing the main light, her torso is rendered without a lighting pattern and therefore lacks form. In example 114, we reversed her position so that her torso was turned away

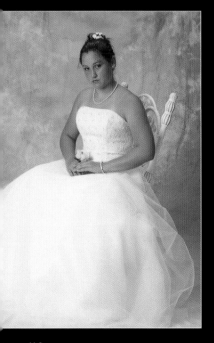

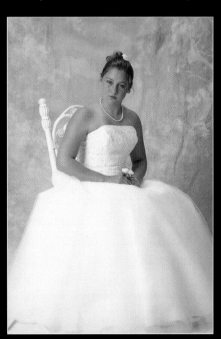

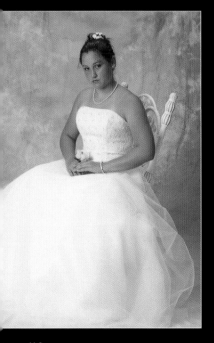

image 113 *image 114* *image 115*

from the main light. This achieved two objectives. First, the shadow from her right arm reduced the expanse of the white gown, which immediately caused her to appear slimmer. Second, the lighting pattern from this position created a form that is much more attractive. The shadow side of the lighting pattern now flatters her bustline, and the shadow to the right of the image adds to the illusion that she is slimmer.

In example 115, we increased the illusion a little more by having her head tipped toward her right shoulder. This is a subtle method of taking your eye away from the figure so as to focus on the subject's head pose. Note that in all three examples, her hands and arms are posed in a circular pattern that takes your eye back to her face.

In examples 116 and 117, we faced the subject into the main light and allowed her to stand as elegantly as possible without any positioning influence other than her angle to the camera. While in example 116, this was a natural thing for her to do, it did not make her look as slim as she would like. Also, the pose was too stiff, and we did not achieve a slight S curve as desired. In example 117, we had her hold a flower so that her arms formed a circular shape that lead us to her face. Her right arm and hand cut across her tummy and less of the white gown shows. We had her very slightly lean her shoulders back and tip her head to our left, creating the desired S curve. But in example 118, we have turned her away from the main light and

THE SHADOW FROM HER RIGHT ARM REDUCED THE EXPANSE OF THE WHITE GOWN, WHICH IMMEDIATELY CAUSED HER TO APPEAR SLIMMER.

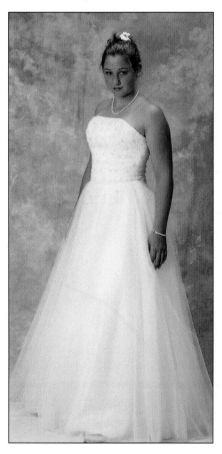

image 116

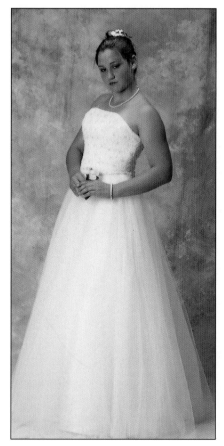

image 117

allowed the lighting pattern to aid our objective as in examples 114 and 115.

Example 119 shows a fairly common pose of a young woman in a gown. The chair was used as an attractive prop, but it did not flatter the subject's figure. She appears too square to the camera and exposes her full body width. In example 120, we corrected this flaw by having her turned toward the chair with her hands placed on the chair back. Her right arm now has a gentle line that slopes with a slight curve as it runs across her hip toward the chair. This creates the illusion of her being slimmer than she is. We can do this with the largest to the smallest of our subjects.

In example 121, we positioned the young woman squarely facing the camera. This position presented her without any of the curves that we have previously discussed, and the pose did not flatter her. The resultant pose is boring and makes her look wider than she otherwise might seem.

In example 122, we had the subject stand at a 45-degree angle to the camera with her arms posed as recommended previously to create an attractive line that leads us to her face. The difference here is that we had her turn her shoulders very slightly toward the camera. This in effect causes the shoulders to appear wider in relation to her waist. Note that we had her placing her weight on her back foot and relaxing her front leg, creating a very gentle curve enhanced by the tipping of her head.

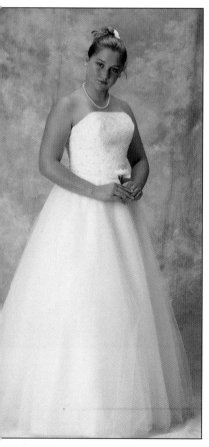

image 118

image 119

image 120

image 121

image 122

image 123

In example 123, our subject is turned away from the light. Her angle was a little more oblique to the camera, and she again turned her shoulders slightly toward us. This and the fact that we allowed the lighting pattern to accentuate her figure makes her look slim.

In example 124, we took a liberty. This young woman had a tiny waist, but we made it look even smaller by positioning her sideways to the camera and having her turn her shoulders toward us. We then had her tip her upper body a little to our left. In effect, her 20-inch waist became 18 inches, or so it appears.

In examples 125–27, we have two young ladies dressed in swimsuits, as this allows us to better understand how refining poses works, without the "disguise" of clothing. In example 125, both were positioned profile to the camera. All the recommended principals we have discussed were employed. In this image, the legs and arms are nicely posed, but because we have no width to play against any narrow perspective, as pretty as the subjects are, the pose does not flatter them or make them look slimmer than they are. Look at example 126 and note the difference. We very slightly changed their angle to the camera and turned the subjects' front foot a little more toward us, creating a lovely, curvaceous hip-to-toe shape. Another refinement was made by having them turn their shoulders toward the camera, creating width at the top of the posing pattern, which, together with the hip-to-toe

image 124

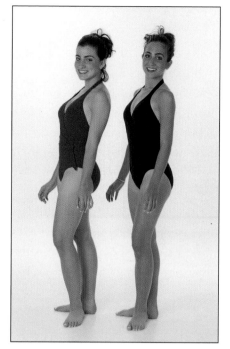

image 125

image 126

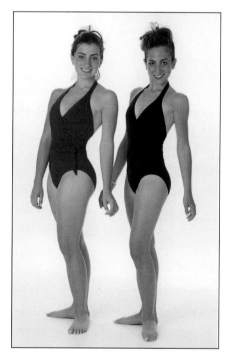

image 127

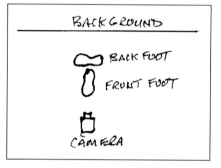

diagram 3

position, creates the impression that the waist is slimmer than it is. This is most emphasized in the pose of the subject in red. Notice that in this example we have also enhanced this subject's bustline. Because the subject in black has her shoulders more square to us, her bustline is not flattered and is immersed in the black tones. After adjusting her position as demonstrated in example 127, we presented both young ladies in a bust-flattering pose and created the impression of very small waistlines.

In diagram 3, we show the position of the feet used in the above-refined images. In ballet, this is referred to as position 3. The position requires the back foot to be approximately parallel to the plane of the camera, with the

heel of the front foot close to the instep of the back foot and pointing toward the lens.

In example 128, the ladies are incorrectly posed. The subject in blue is correctly posed for a slimmer profile, with hips and legs also correctly posed but with her shoulders too sideways toward the camera. The subject in pink has the correct torso pose but has a stiff front-leg pose that causes us to lose the sought-after S curve. In example 129, both ladies were positioned with their weight on their back foot and the front leg relaxed, softening their pose. We have also adjusted the torso position of the young lady in blue and have achieved a more flattering image.

In diagram 4, we demonstrate the position of the hips and shoulders required to achieve the poses we have discussed above. Note that the hips are positioned so that they are virtually in a straight line away from the camera. We then turn the shoulders so that they are angled away from the line of the hips and toward the camera.

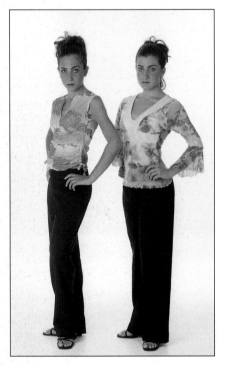

image 128

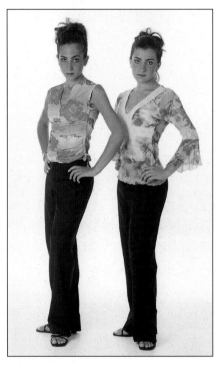

image 129

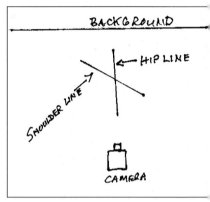

diagram 4

10. Group Portraits

W hen we are presented with subjects for a group portrait, we must first observe the makeup of the group, noting the number of females, males, children, babies, etc. We must also consider the age and body mass of our subjects to determine how they should be placed in the composition. If we fail to take all of these elements into consideration before we start to place each subject in the composition, we will have difficulty in creating a well-designed portrait.

For the photographer and clients, nothing is more irritating than when we must continually rearrange people in order to have each subject both visible and in a nicely designed pose. It is quite remarkable how often this aspect of our portraiture is overlooked, since groups that are randomly created result in a flawed design. When this happens, we have a product that will not do justice to our photography.

Having said this, there are going to be times when we will, for the sake of expediency, make a portrait that is less than perfect and perhaps also less of a success than we would like. This does not mean we will not have more than an acceptable result, only that we will not have achieved a result that measures up to our standards. Having reviewed what must be thousands of group portraits, I have to say that perfection is dependent on more than our individual skills and is obtained only rarely. Often the very makeup of the subjects to be grouped makes achieving perfection difficult. However, this does not mean that we should not seek the ultimate portrait each time we are commissioned.

Bear in mind that the following suggestions are starting points—you may not always be able to achieve any selected composition to perfection. Remember, too, that in any of these suggested designs, we have to make adjustments for size, shape, and individual relationships. It is not intended for any of the designs provided in either the diagrams or the images to be cold architecture.

IT IS NOT INTENDED FOR ANY OF

THE DESIGNS PROVIDED IN EITHER

THE DIAGRAMS OR THE IMAGES

TO BE COLD ARCHITECTURE.

■ GROUPS OF TWO

After single-subject photographs, groups of two are the most common type of portrait. While head-and-shoulders images are often created for newspaper engagement announcements and to record the couple for the family, there are actually many posing possibilities for groups of two.

Our first examples deal with young women with bare arms, a situation that always presents a challenge. In fact, one of our subjects has bare shoulders too.

In example 130, the two young women were composed to show a differential in their height. While this is perhaps more interesting than a straightforward side-by-side composition, it presents a problem in how to pose the lower subject's left arm. Additionally, there is a kind of awkwardness that does not lend itself to a relaxed-looking portrait. The young woman at our right attempts to rest her arm on the side of the chair but does not quite make it. This image is the result of one of those creative notions that does not work.

In example 131, we brought the girls closer together, turning them a little sideways to the camera. This immediately created a more acceptable composition, allowing us to hide the left-hand subject's left arm and create a much nicer line with the posing of their arms. This line is sleeker and much less eye-catching and leads us back to their faces. Note how much easier it is to pose arms and hands when they easily run across the plane of the camera.

This composition allowed us to reduce the emphasis on the bare shoulder of the left-hand figure compared to example 130.

In example 132, the subjects are in reversed positions, and we see a wide view of the young woman with bare shoulders. Again we have the same problem with the left-hand subject's left arm. The hands and arms are relatively acceptable, but as a portrait of two sisters, it will be improved in example 133. In this instance, we have brought the girls together as in example 131. Again, arms and hands look sleeker, the square look of the bare shoulders has been softened, and the girls look more cohesively posed.

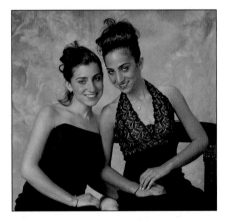

image 130

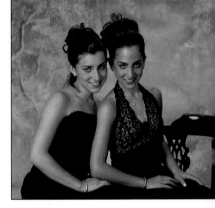

image 131

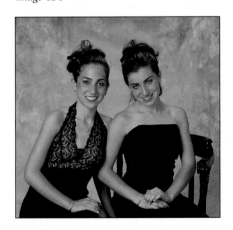

image 132

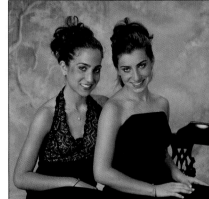

image 133

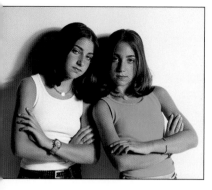

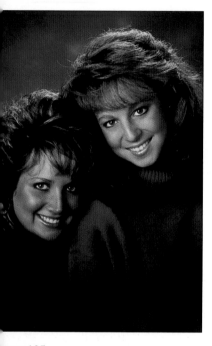

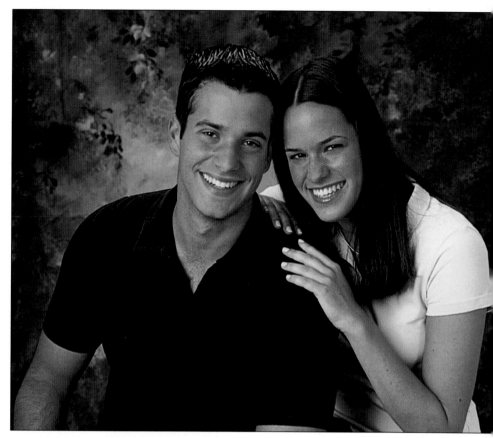

image 136

Example 134 offers an alternate composition for two female subjects. As well as using the folded-arm pose for both girls, note how we brought the right-hand subject slightly in front of the other girl's shoulder. This makes for a much more subjective pose, as both subjects look focused on whatever the photographer was using to draw their attention. This technique is not used often enough, so often groups of two often appear to lack focus.

Example 135 shows a close head composition of two sisters and draws the viewers' focus to only the faces. Note that we have a diagonal line leading downward to our left. This is a much more interesting composition than would be achieved if the two heads were in a side-by-side view.

Male and female compositions can be very simple, or we can be creative in order to make our portraits more interesting. In example 136, we show a relatively conventional engagement portrait but in a relaxed style. We used the male as a prop for the female, who rested her hands on his masculine shoulder line in an affectionate pose. Both her hands were brought close together to emphasize her affinity toward him. Note that we have attempted to show the sides of her hands as was advocated in chapter 4. This also allowed us to reduce the width of her shoulder line, which, because she is dressed in light-colored clothing, would appear much wider if more were to show. In this case, we didn't want a wide view of the female's shoulders because we are not showing her waist.

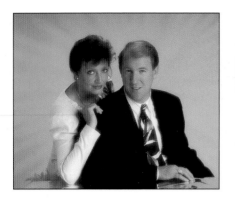

image 137

Example 137 demonstrates an alternative to 136, as it is more formal. With the couple dressed more conventionally, we needed a composition that would support a more formal mood. In this image, we have the male with his forearm resting on a table, which brings him slightly toward the camera. His partner is posed in a different manner than that of the young woman in 136. Her arm and hand are much more sideways to the camera, and she also has her elbow on the table, bringing her toward the camera too. This creates a much more dynamic portrait because the couple is proactive with the photographer.

Example 138 shows an older couple in an outdoor scene, and it is a completely different style of portrait. The composition, a full-length seated pose, displays the longevity of their relationship. Their inherent

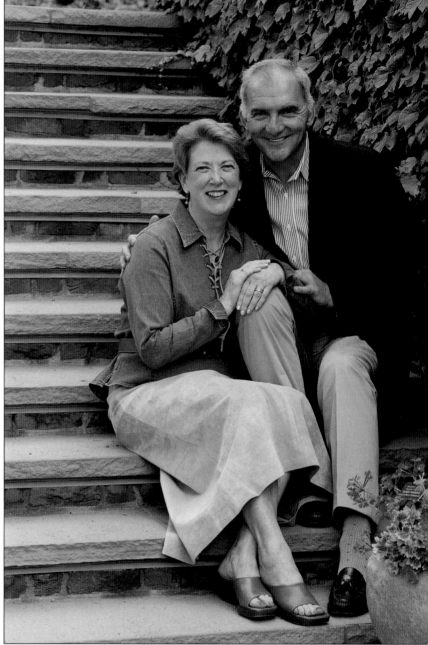

image 138

affection is what this portrait describes. His position presents a prop for her as we have done in previous images. This was achieved by having him sit on a step higher than her, so she could place her hands on his knee and easily snuggle up to him. The placement of her arms was deliberate so as to allow his left hand to gently rest on her left arm while his right hand was gently placed on her shoulder. Notice how we have used the recommended feet pose for the female subject. Additionally, because he was seated on a higher step, we were able to stagger the lines of the man's legs so that his knees do not appear planted side by side and instead present a more acceptable line.

The next three images show a young couple dressed in more formal attire. Whenever we have a male subject dressed formally, with occasional exceptions, a main concern is to retain an acceptable view of his tie, which needs to be seen in a vertical position. This automatically means he must be in a vertical pose too. The occasional exception is when the impression we are seeking to create is one of a relaxed attitude similar to those used in fashion-type photographs. However, when we are creating portraits for our clients, they will readily complain if his tie is not properly set in the frame of his jacket. So, in examples 139–41, we seek to have the young man's tie properly set.

WHENEVER WE HAVE A MALE SUBJECT DRESSED FORMALLY, WITH OCCASIONAL EXCEPTIONS, A MAIN CONCERN IS TO RETAIN AN ACCEPTABLE VIEW OF HIS TIE.

For this series, the couple was invited to sit in a comfortable pose. The young lady sat beside the male and placed her hands on him as suggested. In example 139, you can see how, without our intervention, his right arm rests on the arm of the chair and his hand simply dangles lifelessly. Additionally, his left arm rests impassively, adding extra width to his body mass. The expanse of his dark-toned jacket makes his hand an object of immediate attention in the image. Even if we had brought his left hand across his body to join with his right hand, and adjusted the young lady's position, his hands would still demand our attention.

To remedy this situation, it was necessary to switch the subjects' positions in order to achieve an acceptable pose of their hands and arms. This is done in example 140. Note how in this image, the young woman is in a closer position with her head close to his. Their hands and arms were brought together to create a stronger impression of his hands and to make an important connection between them.

Example 141 shows an alternate pose. While we still retain the connection, much of the dark jacket now extends beyond the center of our portrait, resulting in a composition that is not as presentable as the pose in example 139.

When posing couples in a standing portrait there are a number of options, and in the sequence of poses shown in examples 142–45, the varied impressions were created by subtle changes. In this series, we have not

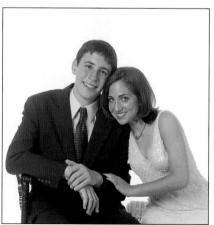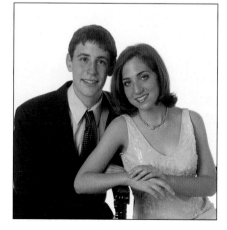

image 139

image 140

image 141

asked the young man to change his pose; we have simply changed the female's position. Note that we have used the feet positions discussed in chapter 5. In each of the images, the young woman has her feet and legs positioned so that there is a break at her knee that creates a very slight

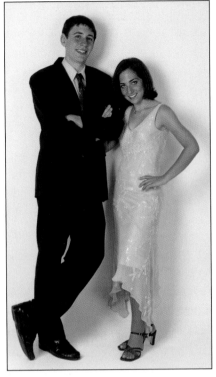

image 142

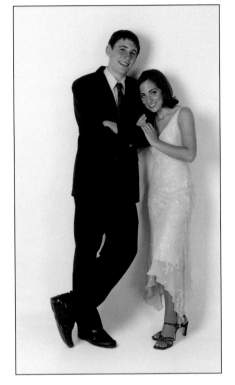

image 143

IN EACH OF THE IMAGES, THE YOUNG WOMAN HAS HER FEET AND LEGS POSITIONED SO THAT THERE IS A BREAK AT HER KNEE.

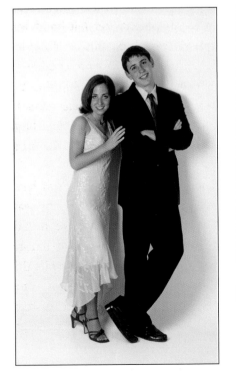

image 144

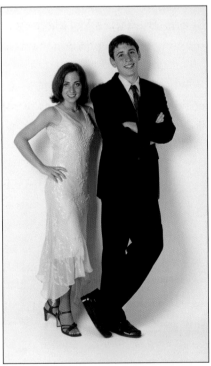

image 145

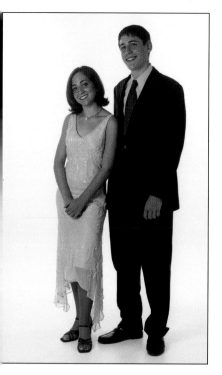

image 146

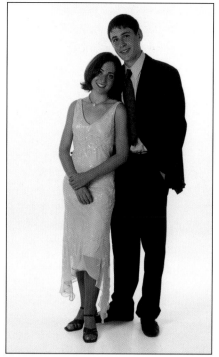

image 147

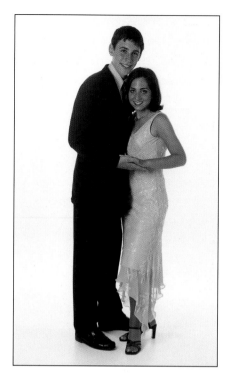

image 148

S curve. There is a distinctly different impression in each of the four portraits, each due to the way in which the female subject is positioned and posed.

In example 146, the couple is shown standing in a fairly typical pose. The female subject has her hands clasped together in a style that I never permit for males—the fig-leaf position. In example 147, three subtle changes were made. The male's left hand was placed in his pocket; her left hand was moved to rest on her lower forearm, and she leaned into his far shoulder. The resulting pose is a natural one but is warmer and more presentable.

In example 148, we created a more formal pose by repositioning the young woman to his other side. Again, using feet positions discussed earlier, we brought the subjects together to create a warmer impression. Note how his hand is placed below hers so that it does not dominate the more delicate female hand.

When preparing to photograph a couple when the male is a full head taller than the female, we may wish to reduce the height difference by seating them in a creative way. Example 149 shows the male seated on a chair with the female seated on its low arm in a rather daring pose—one that she would never dream of if she were wearing a dress or skirt. But, despite this type of pose generally being inadvisable, it can be acceptable for some clients simply because it is so casual. Here, the fact that the subject is wearing slacks and is a very attractive young woman perhaps allows us to get away with such a presentation.

In example 150, the male subject's position is unchanged, but the female has been seated on the slightly raised arm of the chair. This brought her

HIS HAND IS PLACED BELOW HERS

SO THAT IT DOES NOT DOMINATE

THE MORE DELICATE FEMALE HAND.

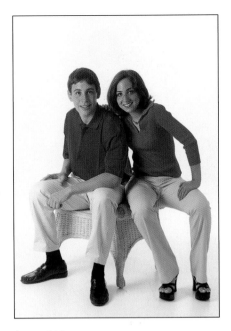

image 149

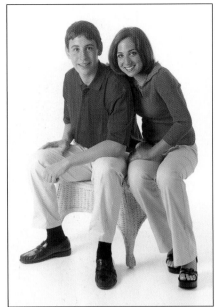

image 150

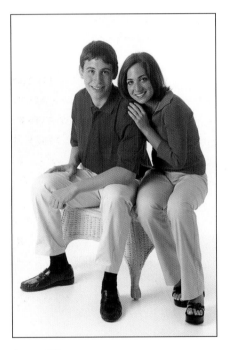

image 151

image 152

NOTE HOW THEIR HANDS AND ARMS WERE

POSED TO CREATE AN ALMOST

CONTINUOUS LINE.

head into a more pleasant relationship with his and also allowed her to tip her head slightly toward his shoulder. We used the feet positions discussed in chapter 5, and the hand and arm positions discussed in chapter 4. Note how their hands and arms were posed to create an almost continuous line. Note too that the manner in which she is seated presents a slim line from head to toe. In example 151, we simply placed her left hand on his shoulder, warming the impression in the portrait.

In example 152, we used a technique that is suitable for the more casually dressed couple. This time she is seated and he is kneeling beside the

image 153

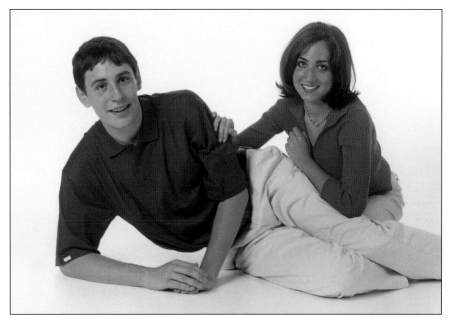

image 154

chair. This retains the differential in height without making it scream at us. Again we have used the feet and hand positions discussed in chapters 4 and 5.

Example 152 shows a tightly cropped floor pose similar to that referred to in chapter 8. Again, we retained the differential in height, but in a warm, fun type of pose. Note that we posed the hands and arms to create a circular leading line to the focus of the portrait. Also important in this image is the cropping of the female legs. This crop line does not suggest an amputation of the legs at any point, as it shows just enough of her upper legs to create an acceptable composition.

Example 153 offers a more playful floor pose, using the male as a prop for the female subject to rest on while she sits on her knees behind his leg. This is an option for a brother-and-sister portrait, but it does not have the warmth that would be appropriate for an engagement portrait. This is also a position the two might take if they were watching TV. We have simply tidied it up.

Note that you will find more information on posing couples in the chapter on posing brides and grooms.

■ GROUPS OF THREE

In most cases, groups of three are comprised of parents and children—and this can present some unique posing challenges. In example 154, we use a floor pose in order to get control of the situation. We need to position the hands and arms as we have previously discussed, but there will be times that this may not be strictly as desired. In this image, we might seek to also have the feet that extend beyond the core composition moved more behind the frontal plane so they are not so obvious. However, our clients will be

NOTE THAT WE POSED THE HANDS AND ARMS TO CREATE A CIRCULAR LEADING LINE TO THE FOCUS OF THE PORTRAIT.

image 155

image 156

image 157

receptive to this type of pose. Sometimes we may need to take the shot and worry less about some small detail since, in many instances, we may otherwise not get an image at all. However, so long as we are working within our core concepts, we will not be far off in the finished product.

In example 156, a mother and two children were posed so as to create a diagonal composition. The smallest child was positioned to face the camera, while the mom and the other sibling were placed in a three-quarter position. To make a connection, the older child placed his hand on his mom's shoulder.

Example 157 shows a family of three dressed in formal attire. To create this image, the mother was placed in the center, then the two males were brought in on each side. The parents were posed as a couple, and the son was placed in an eclectic composition, though we have a diagonal that runs from the son to the mom.

In example 158, we see a similar image, but this time, the dad is in the center of the composition. The fact that the two women are dressed in white required that he be placed in this position. To have placed him at either end would have resulted in an unbalanced tonal pattern because the white tones would have been condensed in two-thirds of the portrait. In this composition, we keep the balance, and there is a connection between all three subjects because of the dad's white collar.

The triangular line that we seek to create in our images is shown in example 159, a portrait of a mother with her two daughters. The lines travel from the top of mother's head out and down to the feet of the children. At the same time, as in most triangular compositions, there are two short diago-

nals too. Many times we use two diagonal lines in order to create a triangular composition.

Example 160, parents and a baby, is a typical, almost triangular composition with the parents forming another short diagonal line.

Example 161 shows a bride with two flower girls. This time, the two children were posed slightly turned toward each other, with the bride positioned with her chin just at the forehead of the child nearest to her. This composition created a slight loop-like pattern that runs back and forth through the heads of all three subjects. The use of soft lighting allowed us to get away with this composition, as it is not unkind to the child at the left. This choice of composition makes us aware of the lighting available to us, and this will often dictate how we pose our groups.

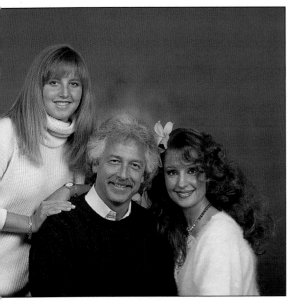

image 158

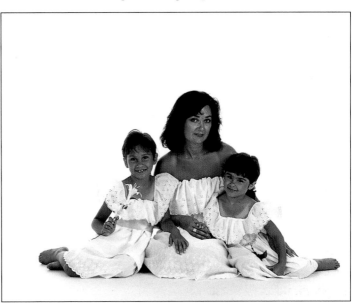

image 159

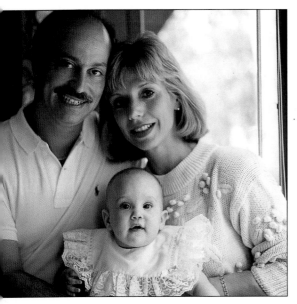

image 160

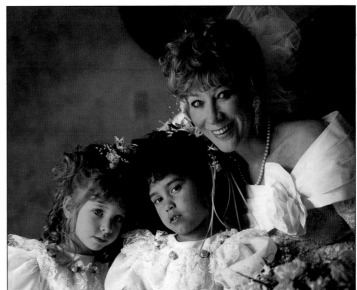

image 161

■ GROUPS OF FOUR

The first examples of a group of four are of dancers. Dancers can provide us with some very useful instruction as to how people in standing poses should look. While they tend to be more conscious of how they position themselves than the average subject, however, they will not be aware of how they are composed within a group, and this is where we are supposed to be the experts.

In example 162, the four dancers are in a square composition with a gentle rolling pattern that is easy on the eye but a little less interesting than the two examples that follow. However, we do have the feet in the recommended positions, and we have used the arm positions to enhance the visual effect by creating leading lines to the dancers' faces.

Example 163 shows a composition in which the dancers are leaning on the background wall using their right elbows. Their legs are posed in a creative position in which the near leg is crossed over the far leg. This is unusual but interesting. Note the diagonal line that runs from the top left to the bottom right. The same diagonal line is used in example 164, but this time, all four figures are connected by having three of them with one hand on the shoulder of the dancer nearest to them, and the dancer at the left perpetuates the motion this creates by having her right hand extended as do the other girls. The sideways view of their arms does not conform to our rules but is acceptable because this is an action-style composition.

In examples 165 and 166, the same group of four is shown in two different compositions. Example 165 is a triangular composition, which runs from the standing figure's head and toward the bottom left and bottom right. The leg poses are a little different than those we have discussed previously; the dancers are shown in more creative poses because the clothing made it appropriate. Note too how we have

image 162

image 163

image 164

image 165

image 166

image 167

positioned the arms and hands, which also create leading lines within the overall composition.

In example 166, we have an eclectic composition with the heads in a staggered pattern, which is more interesting than either a diagonal or triangular line. At the same time, we endeavor to have each figure correctly pose her hands, arms, and legs.

Example 167 shows the same group of young women formally attired and in a standing composition. Again, the eclectic posing concept was used. Note how we have followed our rules for posing hands and arms and how, in doing so, we have the four figures nicely connected. We do not have them touching or holding each other; instead, the flowers they are holding form a line across the composition and visually connect the group.

Wedding groups often provide us with a group of four subjects, and in example 168, we have three figures in black and one wearing white. There are two reasons why we have the lady in black in the center. First, we should acknowledge that she is the most important member of the group, and second, to have the young woman in white centered would cause our eye to gravitate toward the center of the image. The preferred composition allows us to create a triangular group of those in dark attire, which is broken up by the white shirts of the male figures and the blond hair of the mother. Also, the young lady in white has her own focus, without her white dress dominating the composition.

image 168

image 169

image 170

In example 169, a family of four is composed with the three women in a diagonal that runs downward from left to right. The father is positioned in a paternal pose above the three women. Again, note we are following the rules regarding posing the arms and hands.

Example 170, an outdoor portrait of a family with two small children, shows how we might pose them so that all four are nicely positioned within the composition. We needed to have the smallest child held by a parent and chose to have the dad do the honors. Note that in this image, we have four mini diagonals, dad and the little girl, dad and the boy, mom and the little girl, and mom and the boy.

Dad's legs are positioned so they are not in a line horizontal to the camera, a position that allows the younger child to nestle comfortably at his knee. Mom is positioned according to our rules, with her ankles crossed and her hand running down her upper leg. The younger child is positioned

standing between the parents with his right hand on dad's shoulder, while mother has her right arm around him so that he feels secure.

The subjects that appear in example 171 are heavier than average, so we deliberately used a close-cropped composition. With everyone attired in white, there is a possibility that they will appear larger in the image than they actually are. White is an expansive tone, so we need to pose judiciously. Two-dimensional media tends to make us all look wider than we might think we are; that is why lighting techniques are so important and should be used in conjunction with our posing skills to create the impression of three dimensions.

Image 171

Image 172

A space was left between the two front figures that enabled us to create a shadow line on the man's attire and created the deeper shadow on the subject immediately behind. This prevented us from creating a mass of white in the front of the composition, which would have made both front figures look larger than they otherwise might. This composition has a diagonal line from the head of the young woman at the top left that runs to the woman at the right. Also, the three heads at the top of the portrait form a mini triangle, and there is a diagonal line between the two male heads.

While these lines are not the purpose of the portrait, we can see how employing them helps to create compositional patterns that make our groups easy on the eye.

There are other interesting ways by which to design our group compositions. These break away from our basic rules but at the same time use similar design concepts. Remember, we are seeking to create compositions that are attractive to the eye and follow the rules that we have established, making each individual within the design look good.

In example 172, we used the width and strength of the two male

image 173

image 174

figures and employed a very feminine pose for the two females. In essence, this composition uses two separate styles to present a portrait that is uniquely different from the norm. It is more fun than the conventional four-figure composition.

Example 173 shows another innovative portrait that uses all the basic rules we have discussed but presents an elongated composition that, if enlarged to show the subjects near life size, would make an unusual 60 x 36-inch print to hang on the client's wall. In creating this image, we were mindful of the black mass of attire worn by the parents and the older child. Placing the eldest sibling on a box served two purposes. First, it broke up the black mass at the floor level and, second, raised the boy to a height that allowed for an eclectic pattern of the heads of the three figures in black. The figure in white was positioned at the far end of the composition using one of our established poses. The parents were posed in ways discussed previously—the dad is in a strong male pose, and the mom is in an acceptable female pose. The icing on the cake is the boy's pose. By positioning his arms and hands in a triangular pose, we further broke down the black mass. In total, it is an unusual but attractive composition.

Example 174 pretty well breaks all the rules I have spelled out. The females did not take any of the established posing positions. In fact, each of the females in this image is presenting a pose that we might expect from a male figure. This establishes a contradiction in gender attitudes. Females can often pose in male pose and still look good, but males cannot take up female positions without looking weak or unmanly. We created a gentle diagonal line that runs across the three standing figures and connects the group via the hand positions.

Example 175, a family portrait made in the clients' home, uses a more conventional composition but seeks to break with the standard baseline concept. The two male figures were positioned so that we can see the height differential of father and son. The two females were seated in a separate

design that created an attractive base to the portrait. The dad placed his hand gently on the mom's shoulder so as to create a line through the hands and arms of the females that connects them within the composition. Note that we avoided having heads composed in a straight line across the image. The positions of the female arms do not conform to our rules, but the overall composition is quite attractive.

Breaking from tradition does not mean we have to disregard the rules of posing. However, when dealing with families with small children, there will often be something in the image that suggests we have not done our job as well as we might have. In example 176, we positioned a group of four (the baby is so tiny that she does not compositionally make this a group of five) for an image with a little humor. As you can see, the mom, dad, and little girl were cooperative, but the little brother had no real concept of (or apparent interest in) what we were attempting to achieve—hence his attempt to be on his toes, and the humorous feet pose. This posing style offers potential for various groups and is one that I have used successfully and with client approval.

image 175

image 176

■ GROUPS OF FIVE

When working with a formally attired group on location, there are times when there are few, if any, seating props that can be used for posing. Example 177 shows a family of five grouped on the steps of a synagogue. In this portrait, diagonals were used. Two diagonals actually cross each other where the young male is seated in the center of the composition. The hands of the two male figures are deliberately placed to break up the mass of dark clothing in the center of the composition. Note that, here again, the young woman in white was placed at the side of the composition rather than within the main body of the group. The steps were used to stagger the height of the figures within the composition, and we have sought to use the recommended leg poses.

The group of five shown in example 178 is composed in what might be called an unorthodox composition. Instead of utilizing the more common design in which the heads at the top of the group form the starting point of a line that runs downward along the sides of the group, we took a different approach. This design is more interesting because the youngest child is positioned in the center, flanked by her older siblings, without breaking down the family relationship. The key to this pose is the way the line of the heads at the top is staggered rather than symmetrical. Another interesting element within the composition is the way the hands of the figures at the end of the group form a broken line with those of the parents. You can also follow a soft, circular line from the shoulders of the end figures that runs around through the hands of the group. These are conscious considerations when designing a group.

Working outdoors presents many opportunities for creating portraits that will delight our clients. Trees can be a good prop or can be a problem, especially if they are allowed to extend out of the tops of heads or demand too much attention. In example 179, the family is delightfully dressed in black tops and light-colored slacks. The portrait was posed to depict the love these subjects have for each other, so the figures were closely posed, though we could have made a much wider use of the outdoor scene.

Here, the mother forms the base for the composition. She was posed as recommended earlier, resting against the tree. We then added the little person, seating her in her mom's lap. The dad was added next and was placed with his right knee immediately behind mom, and his other knee served as a prop for his left arm. The older girl was placed standing next to her dad so that she

image 177

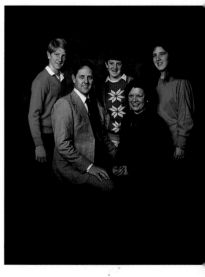

image 178

could rest her head on her dad's shoulder. Last, we knelt the boy as his dad, but at his mom's ankle, so that he too could rest his elbow on his knee. His right arm was extended in order to create a visual connection with his mom, thereby completing the composition. The one flaw is that the back of mom's right hand is exposed to the camera, but this is forgivable because we have created a delightfully affectionate portrait.

■ LARGER GROUPS

Perhaps the biggest challenge in portrait photography is posing larger groups—especially groups of eight or more. There are several important elements we have to consider with these challenges. Our first concern is the composition. This is critical, because if we do not compose the group acceptably, some figures may be partially hidden or may appear insignificant when they should be in a prominent position. Also, if the composition is not carefully planned, it may result in one or more of the subjects not

being correctly lit. An additional consideration is the need to keep families together or arrange the members in a manner that shows the treasured relationships within the group.

With these groups, no matter how much we advise clients about attire, we may also face some compositional problems because of what they wear. Fundamentally, we want our groups to look as though they belong to the same team. We always advise that groups wear soft solids or have uniform upper garments and lower garments that appear to belong in the same color family.

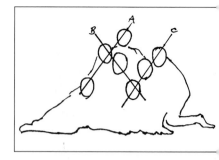

diagram 5

You will face another compositional challenge if your image includes small children. It is often difficult to control a child's body language and keep his or her limbs under control—or they may simply not cooperate at all! In practice, it is often best to set everyone else in place and position the children last. This requires us to know exactly where we want them placed and to have that space available.

Example 180 depicts one of my favorite families. The subjects most certainly dressed as members of the same team, but the patterns of the sweaters were a challenge in composition.

In composing this group, I used a triangular design that incorporates three distinct diagonal lines. The base of the group uses three of our previously recommended seated poses and one kneeling pose. The little girl at

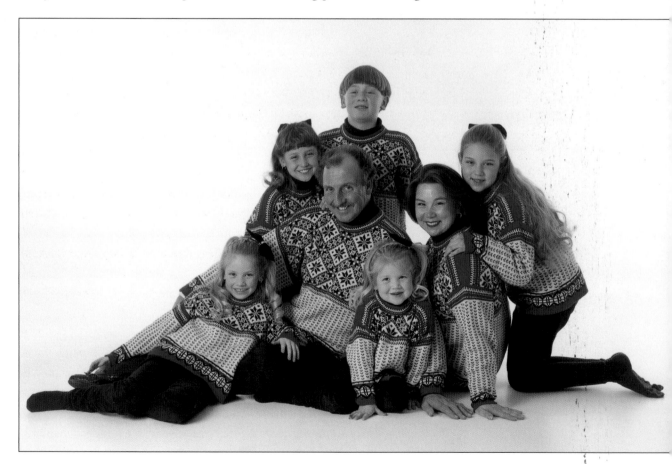

image 180

image 181

the left was originally posed in a more upright position but was asked to lean on her dad's knee, thereby lengthening the base of the group. The dad was posed as recommended but has two of the children in front of him, the smallest in a pose described earlier. The mom was seated comfortably, resting on one hand, and the two older girls were placed at the heads of the parents, with the boy at the top of the pyramid or triangle.

In diagram 5, we show the diagonals used in this example. Creating diagonal, triangular, and circular lines will make designing groups much easier and prevent the need to make continuous adjustments that cause undesirable delays.

In example 181, the family was positioned in front of an airplane in a hangar. The wing of the airplane was used as the main prop, while the balance of the airplane formed the background. All the subjects wore light-colored pants with a range of darker tones typical of bomber jackets. This is a welcome case of the client following our advice.

This composition employs the more conventional top line that curves over the group from the subjects positioned at the end of the group. The kick-over style of leg posing is used for the siblings at the right and left, while the mom and dad are standing with their feet positioned in a relatively formal pose. The smallest sibling posed in front of mom has an innocent presentation, and mom's hands, placed on his shoulders, are perfectly acceptable, as this is what moms do. All the other subjects placed their hands in their pockets to create a nice relaxed standing portrait.

image 182

Example 182 shows a bat mitzvah family-group portrait created at a temple. This image demonstrates how we need to place our subjects to make a group look as natural as possible without the need to make continuous adjustments. The front six figures are divided into two groups of three. Each group was slightly turned into the center with their feet placed as discussed in chapter 5 in order to create a tapered view of the legs of the women. Angling these two groups visually brings the group together, and placing the two male figures at the back at a higher level created a pleasant shape to the composition.

In this group, I allowed the hands of most of the subjects to be loosely placed at their sides, but in order to avoid a boring appearance, I had the mom place her hand on her daughter's arm, and the grandma at the left

placed a hand on her son's waist. The result is a very pleasant and formal extended-family portrait.

Weddings present many challenges in composition and, of course, each wedding is different, but if we use the rules and recommendations discussed in this book, we will largely be able to meet all challenges head on.

Men are usually more difficult to deliberately pose because they are men. We males are much less aware of how we present ourselves and have a need for something specific to do with our hands. Folding arms, placing hands in pockets, leaning against a wall, or resting an elbow on something is a good start, since men are much better "posed" in a natural male position. We can then make minor adjustments without making a big deal out of it.

In example 183, all seven figures are leaning against the church wall with their arms folded and one leg kicked over the other. This is such a natural position for men that, after requesting that they assume this pose, there was literally nothing we needed to do once they were in the desired positions in our composition. The other interesting element in this portrait is that the ring bearer, like all little boys, appears to enjoy being one of the guys.

Example 184 is another in which we placed the figure in white, the bride, at the leading end of our composition. It is my view that this style of composition provides a better focus on the key figure in the group than would placing her in the center. It allows us to pose her independently to the rest of the subjects in the portrait so that she can express herself, without being constrained by her bridesmaids. It also allows us to position her gown trailing behind her so that we see it as it was intended.

This composition also allowed us to show the beauty of the bridesmaids and flower girls, each positioned slightly turned toward the bride. Each young woman had her feet positioned as recommended. Note the position of their arms. They are posed so that the forearm, just above the wrist, is resting on the hip. This will normally mean that the arm is not in a straight

WE MALES ARE MUCH LESS AWARE OF HOW WE PRESENT OURSELVES AND HAVE A NEED FOR SOMETHING SPECIFIC TO DO WITH OUR HANDS.

image 183

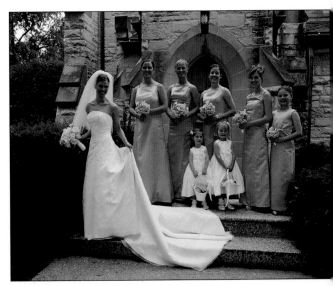

image 184

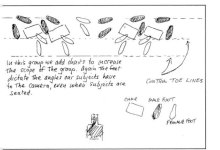

diagram 6

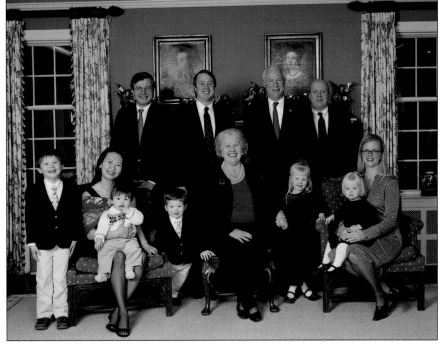

image 185

THE MEN AT THE BACK WERE PLACED

SO THAT NO ONE HAS THEIR

HEAD POSITIONED IMMEDIATELY OVER

THAT OF THE SEATED FIGURES.

line across the figure and also places the bouquets at about the position of the navel rather than thrust immediately under the bustline. This is much more attractive.

The flaw here, if we wish to call it so, is that the two flower girls did not hold their foot positions, which is not an uncommon occurrence.

In example 185, the women are seated on chairs that were placed with space between them, creating an area in which to position two of the children. Note that each adult female subject is very slightly turned so as not to present a broad view, and their legs were posed as previously discussed. The two smallest children were seated on the laps of the women at the ends, while grandma is the center of our design.

I seek to keep family units together whenever possible. The mother at the left has three children, so her kids were positioned close to her, and her husband is the male immediately behind her. Her youngest child was a wriggler, and his position was one we had to accept.

Note that in this image, the men at the back were placed so that no one has their head positioned immediately over that of the seated figures. Additionally, note how the group is placed in relation to the curtains in the background. In the final composition, the little boy at our left is the only figure not in a dynamic place in the portrait, but because of his persona, we are able to accept this as a successful portrait.

In diagram 6, I show a bird's-eye floor plan for feet placement for a group of ten in which four subjects are to be seated. Note the angled position of the chairs, which allow seated subjects to be slightly angled away from the camera. The plan assumes that we are posing five couples, four of which

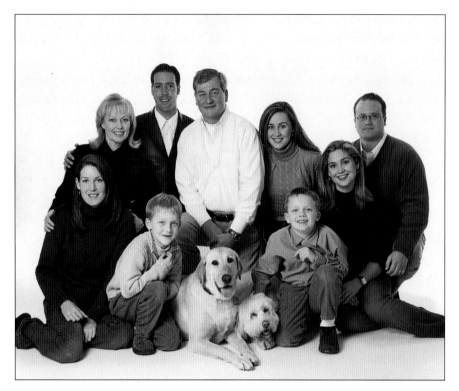

image 186

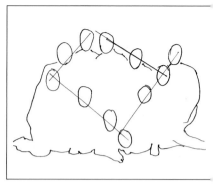

diagram 7

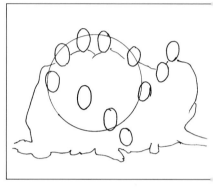

diagram 8

have the female seated, with one couple standing in the center of the back row.

Example 186 is a totally different style of portrait made against a high-key background. A group of nine plus two dogs may present some problems, especially if the dogs are not well trained.

In this instance, I decided it was best to place the dad in the center of the back row because he is the linchpin of the group. I then created four distinct diagonal lines for the placement of my subjects. These are indicated in diagram 7. Additionally, the design creates a circular formation that includes eight of the figures (as shown in diagram 8). These diagrams demonstrate our discipline in following good design when creating group portraits.

In example 187, a group of ten, we split the group into two segments—with four at the front and six at the back. This allows us to have one subject at each end in the back row who creates wings to the composition. The unique style and character of the centered figure was the inspiration behind this design. The character of our subjects sometimes will cause us to modify our ideas, and this is how it should be. This seated subject was positioned in a style all his own, and it suits him perfectly. I then placed his family around him in as casual a style as possible while still endeavoring to stick to our established rules.

Eleven adults and ten children in white and khaki make for a great outdoor family portrait, as shown in example 188. We have adhered to all our established rules while achieving an undulating pattern in the back row,

THE CHARACTER OF OUR SUBJECTS

SOMETIMES WILL CAUSE US TO MODIFY OUR

IDEAS, AND THIS IS HOW IT SHOULD BE.

which avoids a boring, continuous straight or curved line. If you look carefully at this composition, you will find there are six diagonal lines that include at least three of the figures.

Note how two women were seated on the arms of the chairs on which the two centered women are sitting. This raises them a little to avoid straight lines, and at the same time they are nicely posed at an angle away from the camera, with their hands correctly placed in their laps.

The men at the sides have their hands in their pockets, and the older boys at the ends of the composition are posed on one knee, while all the younger children are sitting Indian style.

By almost any standard, this is a very successful family portrait because we have kept to our principles of posing.

I annually photograph a synagogue Hebrew high-school graduation class of teenage students and the faculty. Example 189 is the result of one of these sessions. In creating this image, the first task was to line up the students in order of their height. Placing the tallest student in the center of the back row, we then worked our way outward with the remaining students, moving through the three levels to position the shortest of the students in the front row. We then added the four faculty members at the sides. Before positioning the feet, we made sure that no one was standing directly behind another subject.

Next, from the center out, in both directions, the class was asked to slightly turn inward so that no one was square to the camera. Lastly, we had the front row place their feet as desired. Everyone's feet were in the correct position, with the exception of the lady on the far left, who had her feet in reverse pose.

What we have so far discussed in this chapter is the design factor in creating interesting and acceptable group portraits. We should never randomly create groups that present our subjects in a style that is either disorganized or unwieldy. We should think of ourselves as flower arrangers, always

image 187

image 188

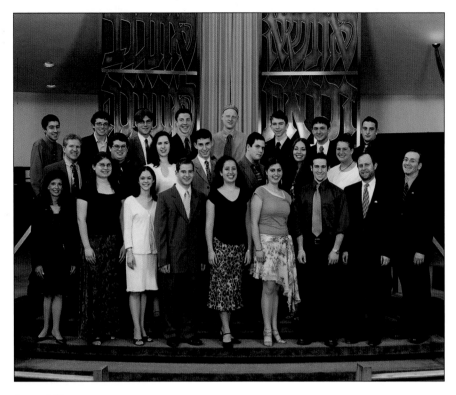

image 189

seeking to create something that is easy on the eye, attractive, and delightful to the onlooker.

When we have a group to photograph, we should carefully observe the height of each subject, their relationship to the group, what they are wearing, and especially each individual's personality and style. All of these elements are to be woven into a design that includes diagonals, triangles, and circles. We should mentally arrange the various components so that the very first subject we position becomes the key to the entire group. We can then add each subject to the composition, one at a time, consciously aware of the design we decided to create. We will fail in our mission to create a dynamic group image if we simply allow our subjects to randomly group themselves and make our task that much harder. The individual posing techniques we have discussed will play an important part in how the group is tied together and will have an impact on those who will review the portrait.

Nothing will make our work easier than practice, but practice is dependent on opportunity, so we can take a sketchpad into our camera room and make rough drawings of the proposed groups we are going to photograph. We can do this at the time our group arrives for the portrait or at the time of a pre-portrait consultation. We can also do the sketch with our group as an audience and involve them in the creation of the design, so long as we do not allow them to take over the project. Even if they do not become involved in the designing of the composition, they will appreciate what we are seeking to achieve and become enthusiastic in their cooperation in making the portrait.

ALL OF THESE ELEMENTS ARE TO BE
WOVEN INTO A DESIGN THAT INCLUDES
DIAGONALS, TRIANGLES, AND CIRCLES.

My preference is to discuss what I am doing while building the group and expressing my enthusiasm and pleasure in how the portrait is going to look.

■ DESIGN STRATEGIES FOR GROUP PORTRAITS

So far, we have analyzed a number of group portraits and discussed the concepts that were used. That discussion was important because it referred to the various strengths and weaknesses in each grouping. Now, we will start the process of building group portraits from the drawing board. In other words, when we are faced with the task of creating a family photo or other portrait, we should have reliable concepts with which to work with.

Groups of Three. There are numerous options when it comes to posing a group of three, and here I offer just four. Diagram 9 (group of three, design 1) is our standard diagonal, which will be a starting point for many other designs to be discussed. Here, the shoulders overlap, and our subjects are positioned at an angle so that each will appear on a level plane to the camera.

Diagram 10 (group of three, design 2) is a looped design that requires us to have the middle subject placed in front of the other two. In this design, the subject at the top left could have his or her head tipped toward the center subject to create a closer relationship within the group. This design would work well for a family with a small child.

Diagram 11 (group of three, design 3) is a triangular composition that requires us to place one subject at the top behind the other two subjects. In this instance, we have the front two subjects shoulder to shoulder, but we can also have one of the front two with a shoulder partially covering the other frontal subject.

Diagram 12 (group of three, design 4) is a V formation, or, if you prefer, an inverted triangle. This will require the lower subject to be placed in front of the other two. This design is well suited to a family that includes a child.

Groups of Four. Diagram 13 (group of four, design 1) uses the group-of-three diagonal design (as shown in diagram 9), but with the addition of another subject at our left. This produces two diagonal lines and is closely related to diagram 11. In this design, we are proposing that the figure to the left has his or her shoulder a little behind the figure next to him or her.

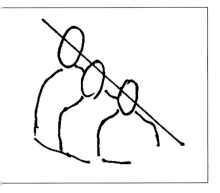

diagram 9

diagram 10

diagram 11

diagram 12

diagram 13

Diagram 14 (group of four, design 2) shows a looped design that can be very successful so long as the figures are slightly turned inward so they do not present a square view to the camera.

Groups of Five. We are now moving into the building-block process as we pose larger groups. In diagram 15 (group of five, design 1), we start with the group of three as shown in diagram 9 and add a figure at the bottom left for a group of four, then add the fifth figure at the top right. By doing so, we have essentially created two diagonal lines within the composition. Note that we endeavor not to place one head immediately above another, though in very large groups, this may be a little difficult.

Diagram 16 (group of five, design 2) adds the fifth figure in the front of the composition slightly to the right of the figure at the top. This retains the diagonals and adds a circle to the composition.

You can see that we are adding figures to our composition in increments of one at a time and keeping to the previously established design principles.

Groups of Six. Diagram 17 (group of 6, design 1) is for a family with four children with one figure, ideally the mother, seated. We use the diagonal line for four of the figures and then place two children at the left of the composition. This accomplishes two objectives. We retain the primary diagonal, which runs from the top of the group to the bottom-left corner. When we add the two smaller figures, we create a more eclectic pattern within the design that we can follow through the front four figures. This prevents the portrait from becoming too symmetrical.

diagram 14

diagram 15

diagram 16

diagram 17

diagram 18

diagram 19

diagram 20

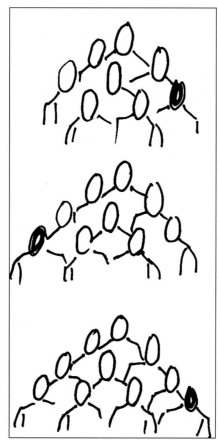

diagram 21

Diagram 18 (group of 6, design 2) uses the diagonal concept in which we have two diagonals involving three figures and a circular pattern in the center. We are simply using the previously discussed concepts to build our groups.

Groups of Seven or More. If we follow the concepts shown above, we can continue to build even larger groups. Diagram 19 (group of seven) shows how we have simply added another figure to the arrangement shown in diagram 18, but with minor adjustment. In diagram 20, we show how we can add figures eight, nine, and ten without moving any of those we have already positioned. We can add figures using this basic concept until we run out of space. Little adjustments may well be required in order to keep the group together, but we will not have to make any fundamental changes to the design.

In diagram 21 (group of 13), we make a change in the basic design. This time, we start with a design intended for a group of eight, then add a group of five. The group of eight is placed at the left of our composition, and the group of five is positioned on the right. Within the composition there are diagonal lines, but in the overall design we have a sweeping curve that joins the two separate groups. This diagram proves that we may use any two or more of the designs covered previously within the same composition in order to create desirable dynamic compositions. All that is required is for us to decide which combinations will best suit the particular group we are working with. There is virtually no limit to the possibilities so long as we do not lose sight of what we are aiming to achieve.

When working with extended family groups, I like to keep each family unit as close together as possible. In the design shown in diagram 22 and example 190, we have one set of grandparents and two families of four, each of which has two small children. In this example, I have placed the grandparents on a bench in the center of my composition as the foundation of my portrait. The two smallest children are then placed next to one of the grandparents. Next, the two older children are positioned next to their siblings. The two final pieces to the portrait are the parents, who are placed at the back in such a way that their heads are not immediately above those in

image 190

front of them. I preferred placing the ladies at the end of my portrait because they soften the edges; if I had the men placed on the edge, the composition would have had a more masculine look. This also allowed me to present a slightly curved line at the top of my composition. This also resulted in my having a space between the men that is small enough not to be too obvious. In another instance I may well close the gap, but in this case, had I done so, I would have created a much more square format, which was not my intention.

diagram 22

11. Wedding Portraits

W edding photography typically requires a more formal approach to posing. Some considerations and strategies follow.

▥ THE BRIDE

When photographing brides, we want to either create exquisitely elegant and beautiful portraits or those that demonstrate the personality and style of the woman in the gown.

Image 191

When posing my brides, I first want to enhance the beauty of the female form using the posing skills that were discussed earlier. I realize that she is first a woman and a bride second, so the subject will be posed to showcase her womanhood, not simply to show off the gown. The gown is in fact used as an enhancing element.

Seated Poses. In example 191, we show a serenely beautiful image of a lovely woman in a magnificent gown. She is posed at a 30-degree angle from the window and is virtually in profile to the camera with her gown trailing behind her as the designer intended. A feminine impression is created by the lines her pose has created. Her leg has a gentle slope away from her, and her arm has a gentle slope toward her

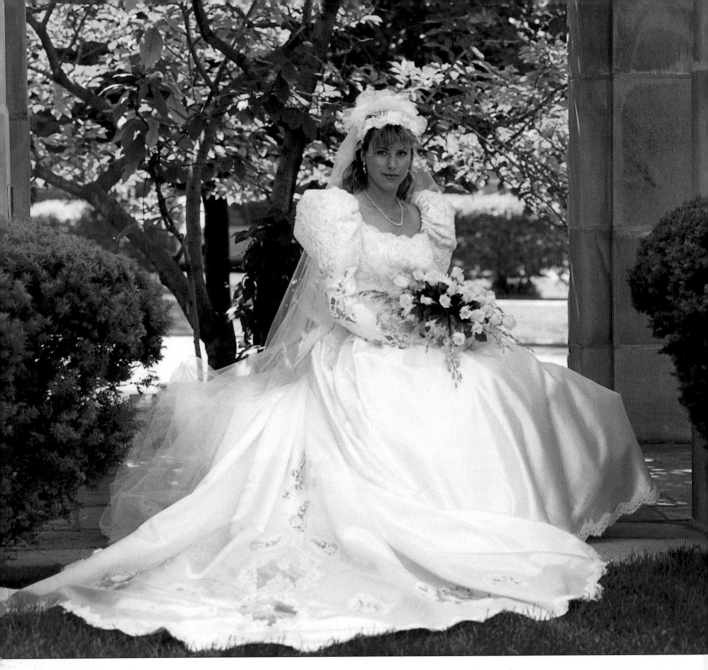

image 192

elbow. We also have a gentle diagonal from her elbow toward her shoulder as she leans gently forward. This slope is continued from her head all the way down her back and to her waist and then is accentuated as the gown sweeps behind her. The angles of her forearm and upper arm make a significant contribution to the softness of the impression we have created. Note also how important the extended toe is to the overall pose.

In addition to the gentle feminine lines we have created, there is also an overall triangular pattern to the pose so that when you view the image you are led back to the beautiful face of the woman. We show this image in a horizontal format, but it could easily be cropped as a vertical.

In example 192, a very traditional seated pose, our bride is positioned at a three-quarter view with her hands and arms correctly posed so her bou-

quet rests in her lap. The gown is properly arranged so that its beauty is clearly seen. There is a nice line that follows her arms and shoulders, leading to her head pose. While this is acceptable, the image lacks feeling or personality. Compare this to example 193. By positioning this bride's bouquet next to her near hip and extending her left arm toward her knee, we immediately create a different feeling to the portrait.

When creating seated poses we have other options, especially when we have props available like the pedestal in example 194. In this image, our bride is presented in a typical female leg-over-knee pose. I do not generally recommend this particular position since it hinders gentle flowing lines, but in this case she is presenting a very relaxed and casual pose, thereby making it acceptable. Using this same pose we can also move the camera a

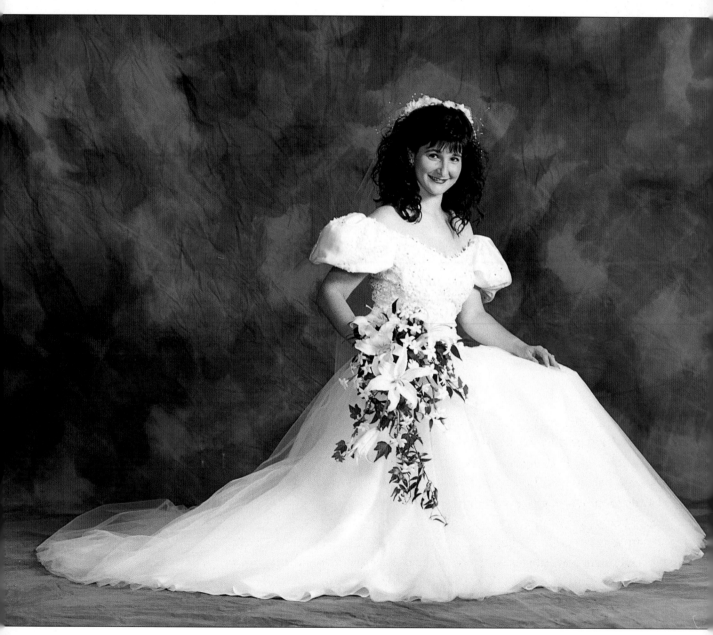

Image 193

image 194

image 195

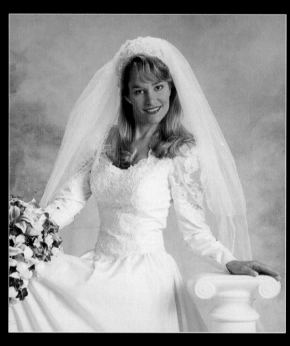

image 196

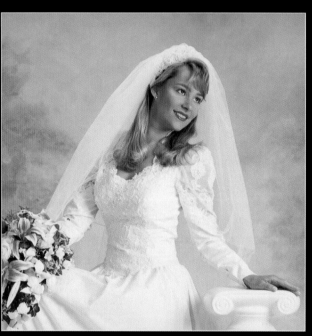

image 197

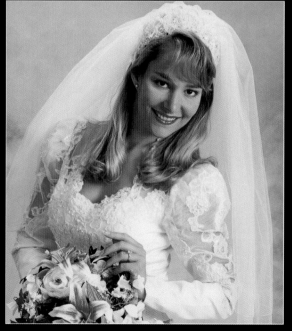

image 198

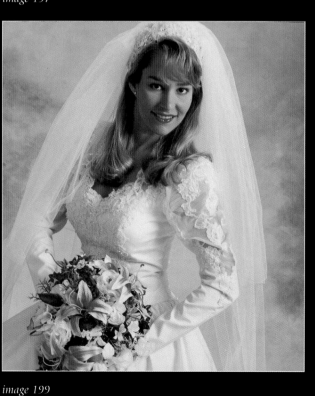

image 199

image 200

little to our left and come in for a closer cropped portrait, as shown in example 195. By moving the camera and cropping our portrait in the camera we have created a different pose that is much more acceptable and attractive. Note too that her front hand is gently grasping her gown and appears proactive. The position of the bouquet keeps the viewer from seeing a fist-like position of the bride's other hand.

In example 196, we have reversed her position and lengthened the pose. This also creates a more flattering bustline because we are now sweeping our main light across her figure instead of having her face it. This is an important element within our consideration of how we will pose our subject. Note how we have her hand in a proactive pose. Note too that the upper area of the arm she is resting on is angled in order to avoid a vertical, more masculine impression.

In example 197, we have brought our bride into an upright, seated pose and positioned her hand and arm in a nicely curved line, with the hand in the recommended position. Her right arm is extended to her knee, where the bouquet hides the hand that holds it. The one flaw here is that her leg forms a horizontal line across the image. The fact that she looked away from the camera creates a sort of sweetness in the image. In example 198, we had her head turned toward the camera for a completely different look that's still a little sweet.

Example 199 shows a classic seated three-quarter pose. It conforms to all our preset rules. Our bride is turned away from the main light with her head turned toward her near shoulder. This head pose, though positioned toward the near shoulder, is not submissive because she is making a very positive connection with the camera. Her arms are perfectly positioned with the middle of her forearm in line with her hips and her bouquet slightly toward the camera, thereby creating a very pleasing line leading to a beautiful expression and a delightful S curve overall. Another notable point is that the pose and the lighting created a very flattering bustline.

I am a strong opponent of the bouquet being placed immediately under the chin. While it is probably very important to the bride and her family, the bouquet should never be allowed to diminish the presence of the bride herself. It is a supporting element within our posing system and should accent the composition rather than dominate it. In example 200, we have brought the bouquet close to her midriff, brought her left hand over the bouquet in a proactive pose, and have maintained all the flattering elements in example 199.

Example 201 shows a seated portrait made with window light. The bride had bare arms and a much smaller and rounder bouquet, and these facts required us to create a pose that would create a nice line below the bouquet and flatter the bride. This was achieved by having her hold the bouquet with her left hand instead of her right. This prevented us from showing the back of the hand and instead showed her fingers in a relatively elegant pose. We positioned her right hand in a sideways view to the camera. In this posi-

I AM A STRONG OPPONENT OF THE BOUQUET BEING PLACED IMMEDIATELY UNDER THE CHIN.

image 201

IN THIS PORTRAIT, WE HAVE BROUGHT HE

VEIL AROUND HER ARMS IN ORDER TO

SOFTEN THE OVERALL LINE ON THE LEFT O

THE IMAGE.

tion, the fingers of the right hand were presented in the longest view possible and were brought a little under the fingers of the left hand. Therefore, the hands have a separate subcomposition within the overall composition.

Note that in this portrait, we have brought her veil around her arms in order to soften the overall line on the left of the image.

Standing Poses. Standing poses of our brides present a challenge if there are no props, such as chairs, pillars, or other solid objects. Women are much more comfortable without these objects, but nevertheless there is a required technique. Without something to either hold on to or rest a hand upon, we are relying entirely on the rules we set about the positioning of

the feet. In example 202, our bride is standing in an open area without any props. In effect, she is posed in profile to the camera with her head turned toward us. Her hands are correctly positioned, but her bouquet is extended in front of her, which is not the best choice for this view. While she is elegant and holds a very nice body position, the pose is a little too stoic and is softened only by her expression. The strong element in this pose is the way in which her gown is placed to showcase its beauty. In example 203, we correct one or two of the flaws in example 202. Having this bride hold the bouquet nearer to her front hip does this. This achieves two objectives. First, the hands are hidden by the bouquet. Second, it helps turn her very slightly across the camera, thereby widening the shoulder line and slimming the waistline.

In example 204, we show our first standing pose using a prop, this time a high-back chair. This is a beautiful image created with window light. It is elegant and dramatic because of the light and the low-key background. However, the position of her arms displays a foreshortened forearm, something we would prefer to avoid. We could have avoided this if we had her a

image 202 *image 203*

image 204

image 205

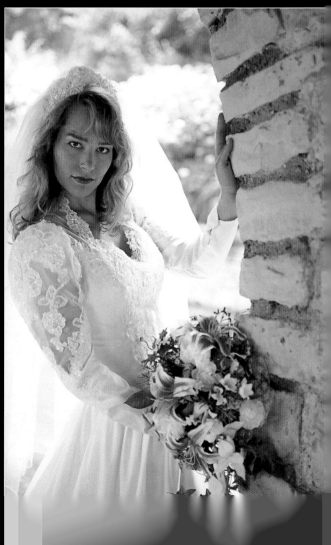

little farther away from the chair and positioned at more of a three-quarter view to the camera.

Example 205 has a better view of the bride's arms, primarily aided by the fact that the chair does not have as high a back as that in example 204. In this portrait, our subject is holding her bouquet, which is also resting on the back of the chair.

We can take advantage of any pillar or wall, doorjamb, or other vertical support against which we can pose our bride, just as any other subject. In example 206, I have the subject close to the window frame so that she can rest her hands against the frame in an elegant manner. This is an example of an instant when we will break the rule about showing the back of a hand. We break the rule here because we are not having the hand squarely positioned to the camera, as it is more delicately posed. Note there is a gentle curved line that follows her hands to her face.

In example 207, our bride is posed against an arched wall. Her left arm is used to help turn her slightly toward the camera, thereby opening up her shoulders and bustline. Her right hand, holding the bouquet, is at an angle, sweeping down to her stomach as we have posed in previous portraits. Note how she is leaning away from the wall, thereby creating a pleasing curve toward her head, which comes back toward our right.

Creating Motion and Dynamics. If we are not thinking creatively, we may find that our bridal portraits are a little stilted. Whenever possible, we should use strong verticals to create motion and dynamic lines. We can also create motion by having our bride be proactive with deliberate body movements. This will enable her to express herself and delight in her femininity, something that a bride has a little difficulty with because of nerves and the thought that she needs to be very careful in her gown.

Example 208 shows how we created a little motion by using the tree as a prop for her left hand and then having her reach slightly down to grasp a lit-

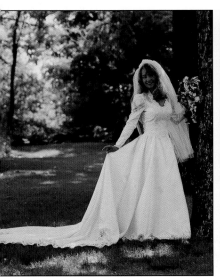

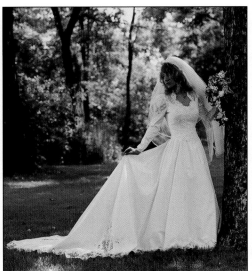

image 208 *image 209* *image 210*

tle gown between her thumb and second finger and lifting it slightly. This created a feeling of motion that is very feminine. Having her push slightly back from her waist, which would also create a more curvaceous line, could have enhanced this pose a little more. This we have done in example 209, and also, we have turned her head profile to the camera and raised her hand as it holds the gown. This resulted in a more curvaceous line and a more dramatic impression.

Creating a feeling of happiness and joy can be done by having the bride take a little gown in each hand (as in examples 208 and 209) and raise her hands in a dance-like pose. If we suggest to her that she should imagine she is dancing and can hear the music, she will generally respond as the subject did in example 210. This image is also enhanced by the strong presence of the tree, which further emphasizes the motion we have created.

Example 211 shows how we may have our bride truly express herself with lots of motion. In this sequence, we have five delightful images, all created within a few seconds and all wonderfully feminine.

Architectural structures offer lots of opportunity for creating dynamic lines in our portraits of a bride. In examples 212 and 213, our bride is using the structure to support her pose and, as she leans away from the support, she creates a dynamic that she would not be able to accomplish without such a support. In example 212, she presents a more elegant pose that is enhanced by the sweep of the gown away to our left. Note that we had her right knee break a little, her right foot extended, and her head a little back to our right so as to create our required S curve.

In example 213, she is posed at the opposite end of the gazebo in a more expressive pose. Note how we had her place her left foot at the bottom of the railing, while she held on to and leaned away from the pillar. These positions created a nice dynamic line from the foot all the way around and to the pillar. This is a simple and effective technique.

image 211

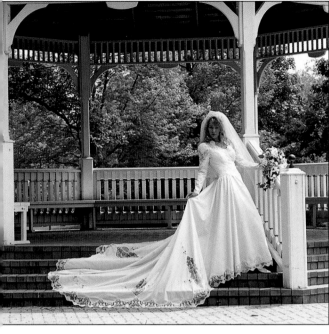

image 212

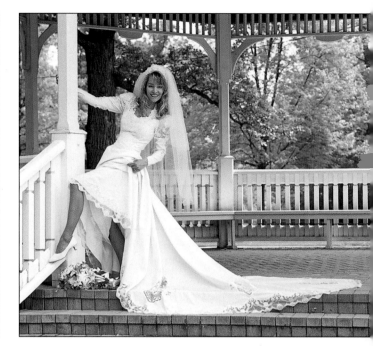

image 213

image 214

image 215

image 216

Given the opportunity to work with a bride with a sense of drama and emotion, we should grab it with enthusiasm. Examples 214–16 show how we can create dynamic and expressive images that are truly exceptional. Each is distinctly different from the other and has strong yet feminine lines. In example 214, the bride expressed contemplation by having her right hand at her forehead. Important to this pose is the placement of her left hand, which creates a leading line running toward her shoulder. Example 215 shows a purely theatrical pose that many women are able to demonstrate. The pose utilizes an impressive line that runs from the bride's right arm, through the shoulders, and down to the bouquet, while example 216

has another expression with a similar mood. Note that in each of these images, the gown is positioned so that it supports the upper-body pose.

In each of the examples we have discussed in this chapter, we endeavored to stick to the rules of posing and at the same time sought to create portraits that are attractive and complementary. We were able to vary each of these poses in order to expand our portfolio of poses.

■ THE BRIDE AND GROOM

When photographing brides and grooms together, we can follow conventional styles or expand our portfolio in order to create more interesting and romantic portraits. While many of our decisions will be dictated by the amount of time we have allowed for these images, we will also be influenced by the couples themselves. However, there are still very important posing considerations for producing portraits that are easy on the eye and do not create distractions by the improper placement of hands and arms, feet, and the angle of our subject to the camera.

Based on the posing rules we have established so far, we know that even bust poses will be supported by the way we place our subjects' feet, and the same applies to head-and-shoulders poses. In example 217, we show a bust

portrait in which the bride was posed at the groom's right shoulder with her figure in profile and her head turned toward the camera. This achieved two important objectives. First, she is shown in a very flattering female position that enhances her bustline and, secondly, it allows the groom's boutonniere to be seen. If we were to pose her on his other shoulder, the boutonniere would be covered. Note too that the bouquet was placed below her bust and in a supporting position rather than in a position that demands our attention.

The groom was positioned at a 20-degree angle to the camera, a pose that allowed her to nestle into his shoulder. This achieved another objective in that it allowed the bride to occupy approximately 50 percent of the image. In this position, she covered almost half of his black jacket, rather than allowing it to dominate the image.

image 217

image 218

image 219

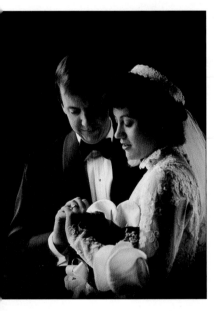

image 220

In example 218, we have a version of the popular "ring portrait." Posing hands for a ring portrait can be difficult because peoples' hands vary enormously, and also the angle at which we approach the hands makes a significant difference. In this example, we have not reposed the couple, but we have taken a profile position to the bride that allows her hand to be seen from the side as opposed to a broad view. Note that she is only placing her fingers onto the first joint of his fingers. This prevents us seeing the back of either hand and also presents a relatively small image of the two hands. At the same time, our position also shows a nice three-quarter portrait of the groom.

Important in this portrait is how we have used the main light to create an acceptable lighting pattern. Additionally, we depart from tradition by placing the bouquet well below the hands, allowing some separation.

Example 219 is another version of the ring portrait, but this time, the groom was placed in profile to allow us a broader view of the bride. The placement of the bouquet and the hand positions are very different, as neither hand is covering the other; instead they are gently touching each other. It is worth noting that there are two distinct diagonals. One is that which follows the two heads, and the other is that which follows her arm and his hand. Also, we are able to see his boutonniere while also having an attractive view of the bride.

Example 220 is a more dramatically lit low-key ring portrait. In this portrait, the bride has a very unusual bouquet, which we used as a base for the

hands so as to show only the part of her hand that has her ring, which is placed on his hand. These three examples show how we can make this type of portrait work for us without making the image just a picture of the hands and rings.

Conventional seated poses of a bride and groom can result in very ordinary portraits, so it is always a good idea to inject a little pizzazz. In example 221, we had the couple seated apart but also close enough that they

image 221

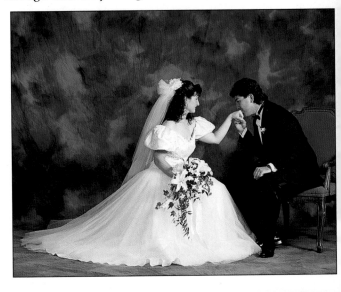

could comfortably reach each other for a romantic moment. Our bride was posed at 20 degrees off-camera to show her gown in all its beauty. Her bouquet was placed at her knee so that it would not sit obtrusively in her lap. In the meantime, our groom was seated profile to the camera and reached out for her hand and brought it to him for the kiss. This is a moment that I have always found every bride to enjoy.

Example 222 is a portrait that captures a private moment between the bride and groom. The couple was seated at a window so that the good light illuminated the bride in her magnificent gown. Both were posed at a three-quarter position. Note that we created a diagonal line that runs from her head down through the

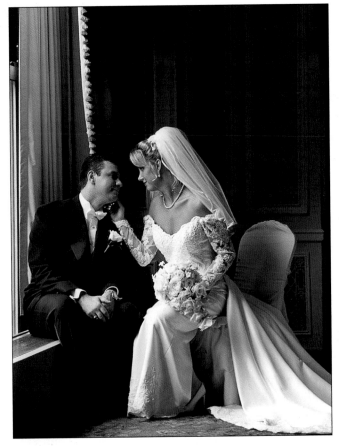

image 222

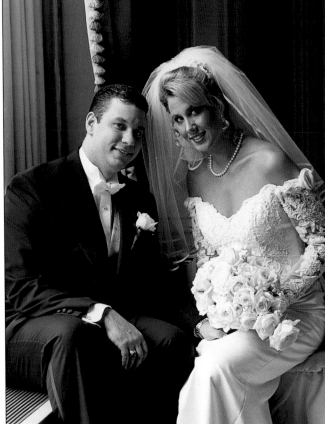

image 223

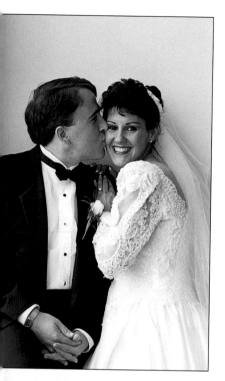

image 224

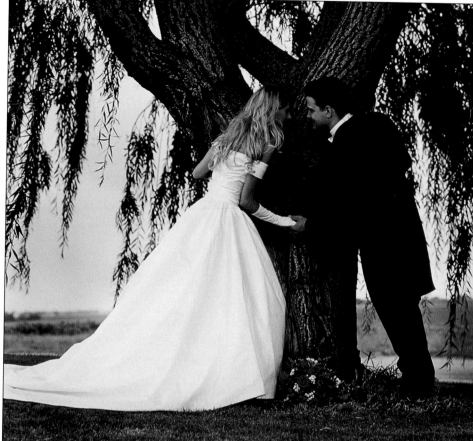

image 225

placement of her gown. Additionally, there is a nice circular line that follows their hands, arms, and shoulders. This pose sets up what we show in example 223, a very casual face-the-camera portrait. This is a not quite formal but very pleasing variation of a more traditional portrait.

Kissing images are common at weddings, and there are many different ways we can pose our couples in order to get a feeling of both having fun with it. Example 224 shows a different style image than that which we are likely to capture at most weddings. Again, we placed our bride so that she would get the best of the window light. She was positioned to hug his shoulder while he was placed square to the camera, and when she turned her head to look our way, he planted a kiss on her cheek. The result is a loving portrait of a bride and groom in a special moment.

Using props such as trees and pillars or other architectural elements was covered earlier, and we return to the use of such props in the next few examples. In example 225, we placed our couple at either side of the tree with her left hand and his right hand holding onto it. This allowed them to lean toward each other, holding hands, and probably about to have the anticipated kiss. This created both romance and motion. We could use a tree, a pillar, a lighting pole, or any other vertical element we may find at our disposal to create an image like this.

THERE ARE MANY DIFFERENT WAYS WE CAN POSE OUR COUPLES IN ORDER TO GET A FEELING OF BOTH HAVING FUN.

image 227

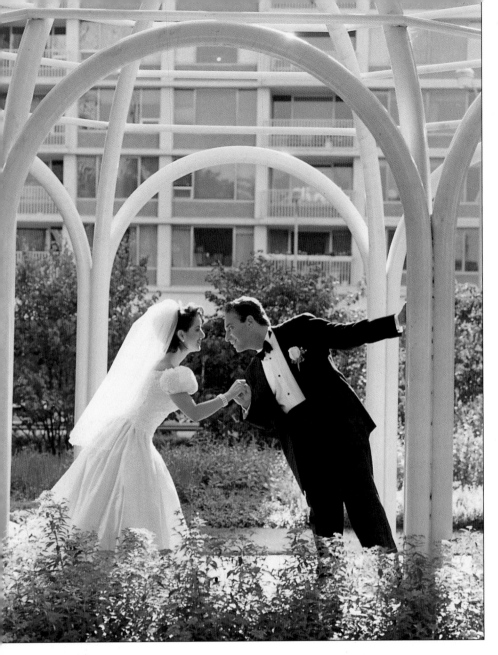

image 226

Example 226 uses a gazebo to create another example of how we can use architecture to create exciting and romantic poses. The vertical and horizontal architectural lines play an important role in this image. The couple was placed far enough from each other to allow the delightful angular lines they create when reaching out to each other. At the same time, their positions form a very attractive triangular shape from their feet to their heads.

Gazebos are not uncommon, and instead of simply placing the couple between the uprights, we should seek to use them more creatively. The actual positions the couples take are going to be based on the rules and guidelines we have previously discussed.

Example 227 is a version of the formal portrait of the bride and groom. The difference is that they were posed more intimately, with her leaning into him as he leans against the tree. This pose is also ready for a variation

THEIR POSITIONS FORM A VERY ATTRACTIV

TRIANGULAR SHAPE FROM THEIR FEET TO

THEIR HEADS.

where they can turn their heads to the camera and be cheek to cheek for the traditional full-length wedding portrait.

Example 228 shows a completely different version of the kiss. In this pose, we have the couple on opposite sides of a fallen tree. Again, the bride was positioned to face the good light. Both rested their hands on the tree, and because the tree separated them, they had to lean toward each other, thereby creating an almost triangular line from their feet to their heads. Though the tree used a lot of our image space, we are still able to see her beautiful gown.

Example 229 shows a bridal couple posed near a window, and again, the bride had directional light falling on her. This pose used the darker areas as a base for showing both her bouquet and gown. Note how we had both subjects take hold of a little bit of her gown in order to give shape to the pose and ensure that she had the toe of one foot showing. The bouquet was extended to her left so that it was shown in relief against the dark area at our right. This is yet another example of how we can use vertical lines to enhance our portraits as well as using the contrasting areas as a base for our composition.

THE BOUQUET WAS EXTENDED TO HER LEFT SO THAT IT WAS SHOWN IN RELIEF AGAINST THE DARK AREA AT OUR RIGHT.

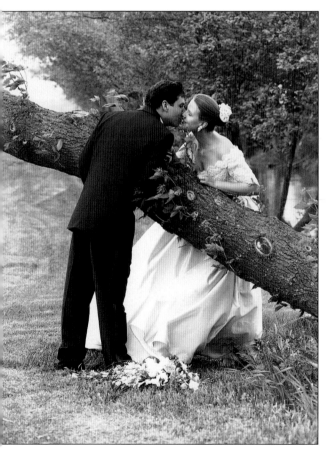

image 228

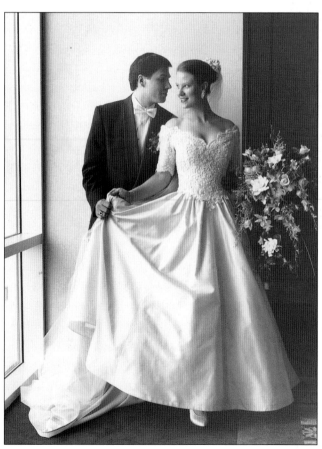

image 229

■ ONE LOCATION, VARIOUS OPTIONS

When working with wedding couples, we should seek to exploit the immediate environment to the greatest advantage. If we stay within a previously established posing formula, we are likely to miss numerous opportunities for the creation of either romantic or otherwise exciting images. This means we should carefully consider the location we are working in and seek out as many "new" styles of pose as we can.

Based on the established posing style we have discussed so far, we can create a series of portraits that are different from what we may have made at previous weddings. In the five portraits shown in examples 230–34, the same setting was used, but we purposefully broke away from tradition. The result is a selection of portraits that allow the personal style of the couple to shine through.

Example 230 uses the recommended posing rules we have discussed. The groom was seated on the railing in a strong masculine pose, and his bride was positioned in a dance-style pose. The resulting composition displays a relaxed but elegant impression of the lighthearted feeling they have for each other on their wedding day.

The bride is shown at a 45-degree angle from the camera but was turned at the shoulders to produce the slimmest waistline and a flattering bustline. Note how her arms are posed, using the hold of the gown as previously discussed so that it extends at a diagonal from her shoulder. Also, her left hand is nicely positioned on the railing to produce the slightest of sloping lines.

Note that her right hand obscures our view of the groom's left hand. This not only creates a link between the couple but creates an interesting interactive composition that is personalized by their looking at each other.

In example 231, we are in the same location but exploit it differently. Our bride is seated and turned toward the groom, who is in a masculine pose that we have referred to earlier. The thumb of his right hand is hooked into his pocket, and his left forearm is resting on his left knee, making his taking of her hand a gentle gesture.

Our bride is seated at the profile position we have previously used. By having her turn her torso toward him, we again narrowed the waistline and flattered the bustline. Her bouquet was placed at about midthigh and extends farther toward her knee. This creates a deliberate undulating diagonal line from her bouquet all the way to his smile.

Example 232 is a more stilted version of the previous example. This is because she is a little too close to his foot position, so she does not lean toward him as he takes her hand. Because of her place on the bench, she is a little too upright, and her pose lacks the motion we created in previous poses. However, the composition is acceptable since it is still somewhat romantic, even if less vibrant. This simply shows us why we need to use more flowing lines in our composition.

In example 233, we created a totally different mood by seating the couple at opposite ends of the bench and initially having them face opposite

THE RESULT IS A SELECTION OF PORTRAITS THAT ALLOW THE PERSONAL STYLE OF THE COUPLE TO SHINE THROUGH.

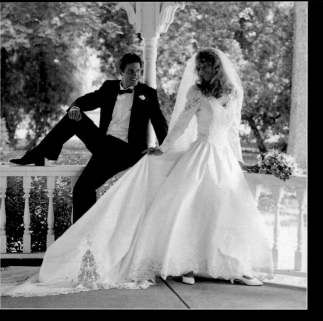

image 230

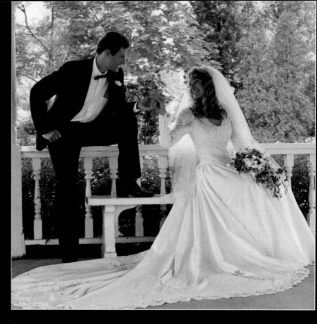

image 231

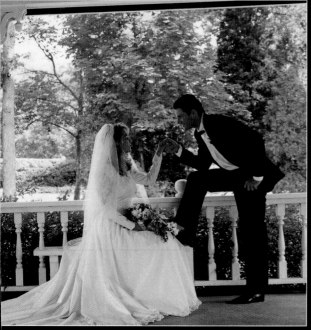

image 232

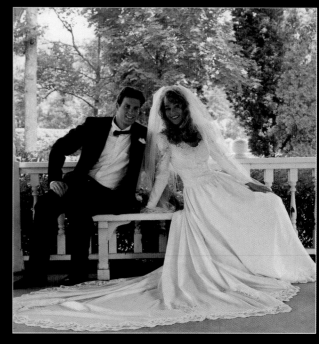

image 233

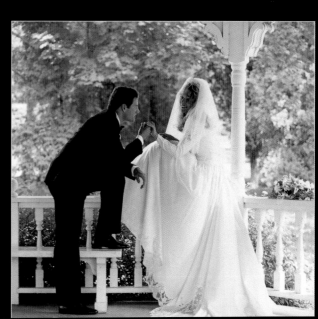

image 234

directions. We then had them rest a hand on the bench so that their bodies cross at the forearm, and their shoulders are virtually touching as they face the camera. This results in a very nice portrait in which there is an almost triangular composition.

Note how we have her with her right hand posed across the camera view with a slight bend at her elbow for a soft line. Her left hand rests at her knee, creating a nice sweeping line all the way to her veil.

Example 234 reverses the roles of the couple, as the bride is seated on the railing and the groom is in a slightly lower position. Her near leg is at an angle we have used in previous examples, and we had her leaning toward him to avoid a vertical pose. In effect, she is in a triangular pose that is incorporated within the total composition. Again we employed the hand pose used in previous examples.

This example shows that by using the posing criteria discussed earlier, we can reverse the couple in a way that allows us to have the female in a posi-

NOT ONE OF US IS SO SMART THAT WE CANNOT LEARN FROM SIMPLY STUDYING PORTRAITS CREATED BY OUR PEERS.

tion that is both unusual and creative and offers more variety.

Example 235 is an unusual version of a much-used composition of the admiring groom and his beautiful bride. This is an example of how we may pose our subjects in such a way that, despite the space between them, there is a very positive connection. Note how we have used the different tones and the architecture to our advantage. Our bride is posed so that the dark tones to our left show her gown in relief, while he is placed against the white pillar at our right. Both are posed as we have previously discussed. Their individual poses and the use of the total space makes for an attractive composition.

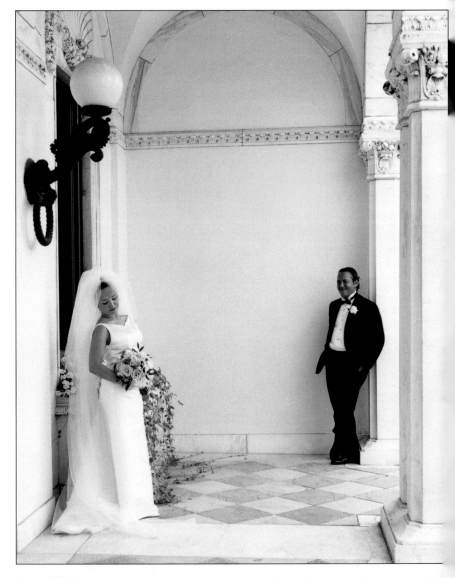

image 235

12. Glamour Portraits

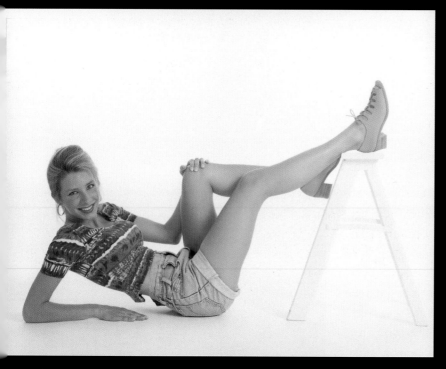

Image 236

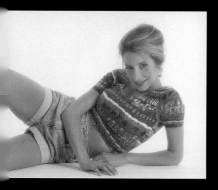

Image 237

Posing females for certain portrait types—like images made for models, actresses, or perhaps for special gifts for husbands or boyfriends—may challenge our ability to produce portraits that are in good taste.

Women may have various reasons for requesting us to produce images that may be a little risqué. If we are to produce these images and not harm our reputation for good taste, there are certain boundaries we should not cross. The main one is clearly established. We will not expose to the camera any part of the female subject's anatomy that may be regarded as risqué. Instead, we may show what might be seen in a number of mainstream media, producing images that can tantalize without showing "too much flesh."

We have previously discussed how we can enhance the subject's femininity by creating the S curve. We have also shown how to enhance the bustline, narrow the waist, and otherwise make her very attractive. We can use all of these techniques and expand on them to a degree without abdicating our responsibility to show good taste.

Example 236 shows a young woman in a pose designed to show what great legs she has, as well as her narrow waist. Her leg poses allow us to view both legs at the same time, something we have not shown before. Previously we have endeavored to create leg poses that taper from the hips to

image 238

the ankles. Here, the legs tend to dominate the image, and we have succeeded in achieving our objective. There is no doubt that this portrait has a touch of glamour with a little fun too.

Example 237 is more provocative still. Note that we are still using the hand and arm patterns that we have discussed. However, in this pose, the young woman is presenting a head pose and expression that is much more inviting. The raising of her right knee leads back to her waistline and enhances the pose. The result is an image more for her boyfriend than for her mom and dad.

Example 238 is the same subject shown in a pose designed to appeal to modeling agencies looking for a beautifully proportioned and physically fit model. Note that we have posed her legs and arms so that we are able to see how slim she is and how pretty her legs are. The position of her hands opens up our view of her bust and also permits her to turn her head for a three-quarter view that allows her hair to cascade beautifully.

image 239

Yet another style of glamour posing requires us to pose our subject so that she can present an expression that is somewhat bold and inviting. Example 239 shows a very simple way to create an inviting image. Our subject was positioned 45 degrees away from the camera so that she had to turn her head back over her shoulder toward the camera, thereby producing the desired expression. This means we see more of her back and shoulder. The expression does the rest.

Examples 240–42 are simply glamorous poses based on the fact that the subject is in a glamorous gown and has expressive arm and feet positions. There is a gentle but strong shape to the images that uses the exquisite white gown and skin tones in harmony. Each pose is different, one pensive, one proactive, and one appealing to the camera. These are very simple glamour poses that can be used for any female portrait need.

Example 243 is a close-up pose that shows enough of a bared shoulder to create a delightfully provocative portrait. The subject may well have been wearing an off-the-shoulder party dress or formal gown, but because we are in tight, you are left guessing. The key to this is that her hair falls so as to hide the far shoulder and so creates a little mystery. Mystery can be an important element in creating glamour portraits because it is part of the female appeal to the male.

image 240

image 241

image 242

Example 244 is an image of a young woman seeking to impress us with her sexuality, which she does very well. The shoulder angle is 40 degrees off-camera, and she is turned opposite to the main light with her head in the submissive position. Because this image has been created in low key, and there is no light falling onto the front of her chest, we see only her bare shoulders, which adds to the mystique. The result is a very provocative image that reminds us that we pose and light for effect. Simply creating attractive composition and effective posing will not be successful—we must also use an effective lighting technique.

Example 245 is a much more suggestive image, as the woman is posed in profile so her shoulder is aimed directly at the camera. Her chin is actually touching her shoulder, and she seems to look us directly in the eye with an inviting expression. The portrait suggests that she may not be wearing anything other than the white boa. The raising of her near shoulder increases that impression.

Example 246 is an image that is much closer to the boudoir discipline but stays well clear of exposing any too-intimate areas. No part of the woman's anatomy is shown that we would not see if she were wearing a

image 243

image 244

image 245

image 246

image 247

bikini, yet the way she is posed with a lovely S curve produces a glamorous and provocative portrait with an appealing peek-a-boo look. You will note that there are no directly vertical limb poses; all of her limbs and her torso have delicately sloping lines.

Example 247 has our model facing the camera almost square on while she turns her head toward her left shoulder to present a delightfully inviting expression. Her arms are posed to show only the sides of her hands, which are placed nicely together in a relatively unobtrusive shape. In this pose, her arms and hands lead us all the way to her lovely smile. This is a very simple pose that, when composed correctly, is very attractive.

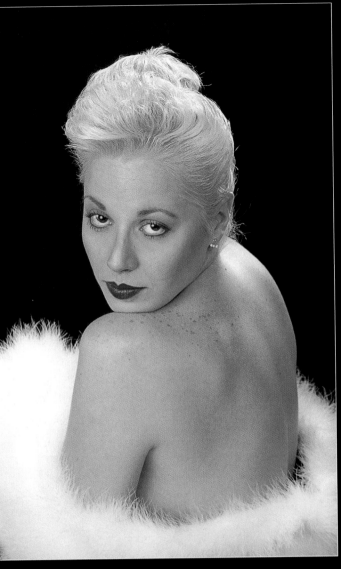

image 248

image 249

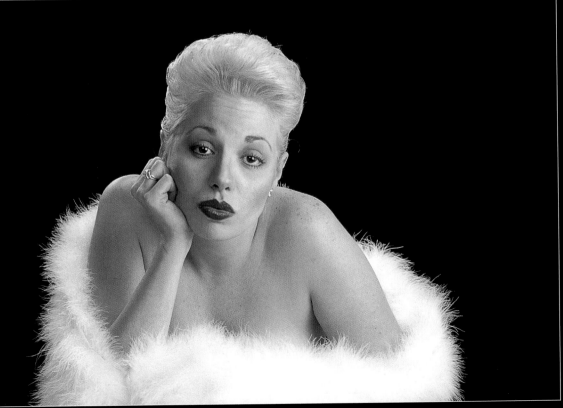

image 250

The three images on the facing page are dynamic examples of how we can create truly glamorous images with a little white texture and a lot of beautiful skin. In all three, the boa is positioned to show just enough to be provocative but not enough to leave us open for criticism. The first example, image 248, shows our subject slightly turned away from the camera to show a bared back and shoulders. She is carefully holding the boa so that it does not show more than is acceptable. Her head is turned toward us, and she has her chin on her slightly raised left shoulder. The slightly elevated camera angle enhances the pose and creates the desired style of image.

In example 249, the subject is slightly turned toward the camera, showing her bustline and projecting her left shoulder toward the camera with her head in the submissive position. Note that we are able to see a little of her right arm too. This makes the overall composition more round and cuddly. The slight tilt of her head to our left completes the line that softly and subtly enhances her expression.

THE DREAMY EXPRESSION COMPLETES AN IMAGE THAT IS SOFT, ESSENTIALLY FEMININE, AND DYNAMIC.

Example 250 may be an example of the ultimate glamour portrait. If we recall the wonderful images of Marilyn Monroe, we will see some similarity in the style of this portrait. The pose presents the subject square to the camera and yet has sloping lines that involve both her arms and the gentle tilt of her head as it slightly falls away from her right hand, which rests on her cheek. The dreamy expression completes an image that is soft, essentially feminine, and dynamic.

13. Freestyle Posing

Many people feel there are limits to how we should express ourselves—and that we should not express ourselves in such a way that our body language seems outside the norm. But if we carried that sentiment over to dance, such as ballet or modern dancing, we would essentially subdue our ability to show our feelings and express emotion—and that would negatively impact our entertainment.

In this following series of images, our model was directed to create self-expression within the framework of the concepts we discussed in previous chapters. In each of the nine poses, she was asked to depict a feeling of motion and to utilize poses consisting of lines that enhanced her femininity. Even is she were to demonstrate self-assuredness, she would need to ensure that the lines in the pose were soft and flowing.

Each of the poses we show is intended to reinforce the concepts and guidelines that we have established so far. In fact, we have created these poses deliberately for educational purposes rather than to depict everyday concepts.

The set on which we have created these poses has many vertical and horizontal lines for us to use in order to accentuate curvaceous and soft, feminine poses. Some of the poses are a little extravagant, but each has a basic design that can be

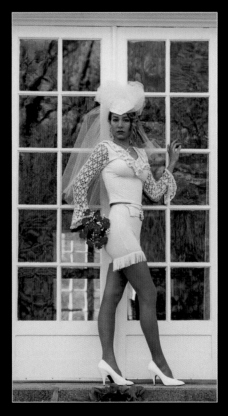 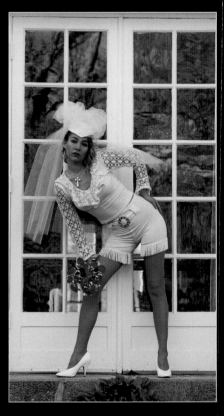

image 251 *image 252*

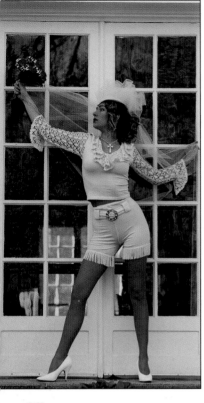

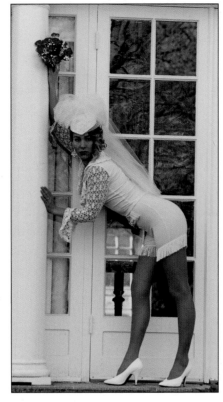

image 253 *image 254* *image 255*

diagram 23 *diagram 24* *diagram 25*

used in other situations, even with a modern bride or model.

In example 251, our model is in a standing pose that creates numerous curves and feminine lines. Note how her right arm, nicely bent at the elbow, has her hand with the bouquet at her hip, and then the line extends down through her right leg. Also, the leg positions create a very nice view of a great pair of legs, and neither is in a stiff straight line.

Her torso is turned as we have previously advocated, showing a wider view of her shoulders and a narrower view of her waist and left arm, which is placed so that it is seen as a soft line against the horizontal lines and verticals of the windows behind her. Throughout this pose there are lots of soft and feminine lines.

In example 252, our model creates another pose—based on her stiffly positioned left leg—that leads us up and around her torso and to her head. Though we have advocated that stiff limbs are not desirable, she breaks this rule with confidence because she has used it to create a series of other very attractive lines in the positioning of her arms, head, and right leg. In fact, you can follow distinct lines from her left leg—one that goes through the

torso and one that takes us through her left arm to her head. There is also a very dynamic line that follows her arms down her right leg. These lines are both diagonal and circular.

In example 253, our model has created a series of curvaceous lines, one that starts at her right foot, moves on through her hip, then up to her torso and head. Another is that which runs from her left foot, around her left hip, and up to her shoulder and head. Then we have another curvaceous line that runs through her arms. All of these are soft, and aside from the stiff left leg, there are numerous curves. We follow these lines in diagram 23.

Example 254 presents one primary sweeping curvaceous line that starts at her left foot and follows her legs around her hip, through her back, and on past her head to her right hand, which holds the bouquet. Additionally, there is a secondary pattern that begins with her left hand and sweeps around her elbow and face. A third line is that which starts at her right foot and travels along her leg, to her midriff, and then to her bust. This third line is simply a supporting element within the composition. This means that we have three separate designs in the same composition. These lines are demonstrated in diagram 24.

Example 255 shows a back view of our model, and there are two sweeping curvaceous lines working in harmony at the right of the image. The first follows from her right foot, all the way past her hip, and through the torso to her head. Bending at the waist and tipping her head in order to look toward the bouquet creates this line. The second line starts at the bouquet and follows her arm up to her head.

The sweep at the left that runs from her left foot and though the line of her left arm produces supporting lines, as demonstrated in diagram 25.

Example 256 shows a seated pose that depicts how we may vary the pose of the legs by positioning each at a different level. However, we are careful to ensure that each has a sloping line at both the lower and upper leg. The sloping line is essential when posing female subjects in seated poses; without them, we will have unflattering vertical and horizontal nonfeminine lines in our composition.

In example 257, we have made a key adjustment so as to create a longer line in the composition of the legs, which now are part of a

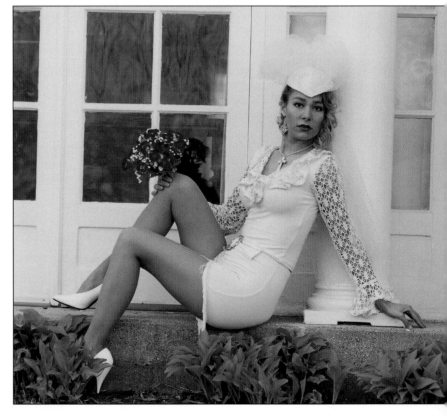

image 256

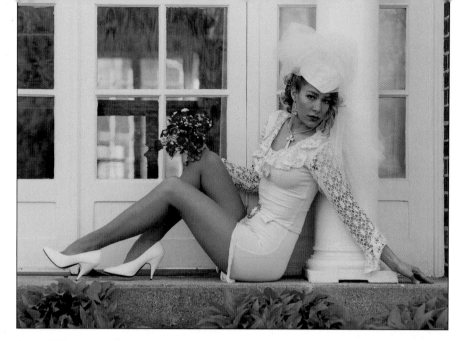

image 257

image 258

more triangular design. This is also a much more flattering view of her legs. Additionally, we have turned her shoulders and her head so that they are in line with her arm. This rearrangement achieves some key objectives. First, there is a longer, sleeker view of her legs. Second, we have a distinct narrowing of the waistline and a much sleeker overall composition.

We can practice posing and perfect it to the utmost degree, but if the total composition does not use a pose for a pleasing effect, we will not have a satisfactory portrait.

In example 258, we changed the mood of the portrait by slightly lengthening the subject's left leg. We had her left hand in a more rested position

and asked her to look skyward. Each time we have a subject change his or her head pose, we will achieve a different mood or expression. In this latter instance, we created a contemplative or perhaps introspective mood with these adjustments.

In example 259, the model was placed at the opposite side of the set, and we accentuated the triangular composition by lowering her far leg and extending it a little farther than the near leg. Her left hand reaches farther down the line of her leg so that it forms a continuous line all the way to her shoulder. She was turned to look toward her bouquet, which is held by her slightly extended right arm. This completes our triangular composition. All the rules we have discussed are incorporated within the portrait—proof that practice can make for perfection.

ALL THE RULES WE HAVE DISCUSSED ARE INCORPORATED WITHIN THE PORTRAIT— PROOF THAT PRACTICE CAN MAKE FOR PERFECTION.

image 259

Conclusion

In this book, we have established several important criteria for posing. While each is important in its own right, we must not consider these guidelines as separate entities unrelated to each other.

Our objectives for any portrait must be to create the most effective representation of the subjects we are photographing. If we are to be successful in this business of portraiture, limiting ourselves to only one or two of the rules and recommendations will not serve our purpose. All the issues we have covered should be practiced and memorized so that they become second nature. If we were flower arrangers, we would attempt to create the most beautiful presentation of the colors and shapes of the flowers we have to arrange. If we were landscapers, we would try to create beautiful designs that would excite and please our clients. The same principles apply to the way we pose and present our clients.

Though we have set out numerous rules, concepts, and designs, what we have discussed and presented is only a starting point for the creative photographer. Everything discussed can be modified and expanded on because there is no limit to our creativity. There is another critical consideration, though, in the way we work—even while staying close to what we have so far covered—we are photographing human beings.

Humans are not objects for molding into a photographer's preconceived image. Each of us has a personality different from everyone else, no matter how much we may we be tempted to categorize each other. Each of us has different levels of sensitivity and emotional response. These are all individual facets that we are supposed to show in our portraits. So when we are using the rules and criteria discussed in this book, we need to incorporate the individuality of our subjects. This means we must be flexible when working with clients and, when necessary, should modify the poses to suit the situation. If a subject is uncomfortable with any of our first poses, we must immediately respond by modifying the pose or shifting to another.

WHEN WE ARE USING THE RULES AND RITERIA DISCUSSED IN THIS BOOK, WE TO INCORPORATE THE INDIVIDUALITY OF OUR SUBJECTS.

If we are an established name in our market, most clients will trust us to produce the style of portrait that will make them happy. It is probably why they came to us in the first place. However, it is a good idea to discuss our concepts with our clients so that we may learn whether what we are planning is acceptable to them. Another response is to simply make one or two changes within our concept so that the client is not just more comfortable but is also offered a wider choice of styles.

ABOUT THE AUTHOR

Norman Phillips was born in London, England and became a U.S. resident in 1980. He is married, has three sons, and lives in Highland Park, Illinois. He frequently returns to London to visit family and provide seminars. The Norman Phillips of London Photography studio, located in Highland Park, Illinois, was established in 1983.

Throughout his career, Norman has been a judge at local, regional, and international print competitions and has presented almost 200 seminars and workshops in the United States and the United Kingdom. He is a frequent contributor to magazines and newsletters including *Rangefinder, Professional Image Maker, Master Photographer,* and *WPPI Monthly.* He has created eight instructional and educational video titles as well as manuals and is the author of *Lighting Techniques for High Key Portrait Photography, Lighting Techniques for Low Key Portrait Photography,* and *Wedding and Portrait Photographers' Legal Handbook,* all from Amherst Media. Norman has accumulated more than 240 images that have earned the coveted score of 80 or better, ten Best of Show ribbons, as well as numerous First Place Awards in various competitions.

Norman is also the recipient of a wide range of honors for his photographic achievements. He has been Registered as a Master Photographer by Britain's Master Photographers Association (AMPA), has a Fellowship with the Society of Wedding & Portrait Photographers (FSWPP), a Fellowship British Professional Photographers Association (FBPPA), a Fellowship Degree from Professional Photographers Association of Northern Illinois (FPPANI), awarded a Technical Fellowship from Chicagoland Professional Photographers Association (FCPPA), Accolade of Photographic Mastery from Wedding & Portrait Photographers International (APM), Accolade of Outstanding Photographic Achievement from WPPI (AOPA), Accolade of Exceptional Photographic Achievement from WPPI (AEPA), Accolade of Lifetime Photographic Excellence, and Recognition of Contribution to the Industry from WPPI (ALPE). He is an Honored member of the International Executive Guild. Four of his images were included in the World Council of Professional Photography Traveling Exhibit.

Glossary

Bust pose—An image that includes the subject from the head to the ribs.

Chicken-leg pose—Describes a foreshortened view of the forearm that resembles a chicken leg. The same may be the case in a leg pose.

Duck's feet—Placement of the feet in a manner that resembles a duck's feet by having them pointed directly at the viewer and also slightly apart.

Feminine head pose—The posing of the female head tipped toward the shoulder nearest to the viewer.

Fig-leaf pose—Hands positioned together, one over the other, and placed immediately in front of the person's fly or zipper.

Head-and-shoulders poses—Poses that include only the head and shoulders of the subject.

Headshot—Mostly a photograph of the subject's head with perhaps a little of the shoulders and with the person facing the viewer.

Main light—The light that produces the primary lighting pattern and is designed to model the subject.

Masculine head pose—Posing the head tipped away from the near shoulder so as to present the subject as a character with strength.

Photographic amputation—Describes a pose in which part of an arm, leg, or hand is cropped off.

S curve—The posing of a female figure so as to produce a curvaceous line that resembles an S.

Split lighting—A lighting pattern that presents the subject well lit on one side and in shadow on the other.

Three-quarter poses—A portrait that includes the subject from the head to approximately the knees.

Vignette in—Increasing the density of an image elliptically at the edges and fading to normal at the focal point of the image.

Vignette out—Decreasing the density of an image from its focal point, sometimes to zero, in an elliptical shape toward the outer edges of the image.

INDEX